A GUIDE
...... *to*
historic
Hartford
CONNECTICUT

Daniel Sterner

Charleston — London

THE
History
PRESS

Published by The History Press
Charleston, SC 29403
www.historypress.net

Cover image courtesy of Tomas Nenortas. Postcard is titled "Main Street, Looking North."

All maps are by author.

First published 2012

Manufactured in the United States

ISBN 978.1.60949.635.7

Library of Congress CIP data applied for.

Contents

Preface

This book presents twelve historical tours of Hartford, the capital city of Connecticut. Each tour focuses on a different section of Hartford, with numbered sites of historical interest. The tours are each accompanied by a map (all of which are oriented with north at the top of the page). The maps are not to scale, but I hope that they will be helpful in navigating the busy city streets. It will be helpful if you also have a map of the entire city.

The tours vary in the distances they cover. Some are ideal for walking, while others traverse greater distances and are designed as driving tours. I hope you will enjoy discovering the many people, places and events that have shaped the city of Hartford and had an impact on the history of the country and the world.

In 1635–36, the Puritan congregation led by Reverend Thomas Hooker migrated from Newtown (now Cambridge), Massachusetts, to what would become Hartford, at the confluence of the Connecticut River and the Little (later Park) River. In 1636, the settlements of Hartford, Windsor and Wethersfield united to form the Colony of Connecticut. Inspired by Reverend Hooker's famous sermon in which he declared that "the foundation of authority is laid in the free consent of the people," the three towns, in 1696, ratified the "Fundamental Orders of Connecticut," which some consider to be the earliest written constitution (and which later earned Connecticut the title of the "Constitution State"). The General Court, the new colony's first legislative body, began meeting in Hartford. Under the charter of 1662, Connecticut absorbed the Colony of New Haven, and in 1701, the legislature first began alternating sessions between Hartford and

New Haven. The state continued to have two capital cities until 1875, when Hartford became the sole capital.

Early Hartford was an agrarian society established in an area of meadowlands made fertile by periodic flooding of the Connecticut River. Benefiting from the town's location at the head of navigation on the river, it also became a center of commerce. Settlement focused on Main Street and areas adjacent to the river. By the late eighteenth century, the population reached more than five thousand people. In 1784, the city of Hartford, now to be led by a mayor and city council, was incorporated. It originally included only 1,700 acres centered on downtown, existing within the separately administered town of Hartford. By 1896, the city had expanded to include the town within its boundaries.

In the nineteenth century, Hartford grew rapidly and became a prosperous center of banking and manufacturing, with Colt firearms being just one of its numerous industries. Hartford would achieve particular fame as the "Insurance City" and is still home to such companies as Aetna, Phoenix, Travelers and The Hartford. A center of publishing, Hartford attracted writers, the most famous being Mark Twain and Harriet Beecher Stowe. Waves of immigration transformed the predominantly English town of colonial times into a multiethnic city. Areas beyond downtown were increasingly developed, and by 1870, the population was almost thirty-eight thousand. Between 1890 and 1900, there was a 50 percent increase in population.

Since the mid-twentieth century, the city has faced many challenges. The population reached a height of more than 177,000 in 1950 but has declined since then. The departure of industry and urban decay made Hartford an early testing ground for renewal projects, whose benefits have been much debated. In recent years, an active arts scene and important projects such as Riverfront Recapture, the Connecticut Convention Center and the Connecticut Science Center have brought new visitors into the city. With major corporations, as well as notable educational and cultural institutions, Hartford continues to be an important business center and the seat of state government. With more than 375 years of history, Hartford has much to offer those who take the effort to explore this historically rich community.

The major source for the construction dates and the architects of Hartford buildings is the three-volume survey of Hartford architecture, published in 1978–80 by the Hartford Architecture Conservancy, as well as *Structures and Styles: Guided Tours of Hartford Architecture*, by Gregory E. Andrews and David F. Ransom, published in 1988. Both works are listed in the bibliography.

Many of the photos in this book were taken by the author. For use of the many historic images, I would like to thank Tomas Nenortas of the Hartford Preservation Alliance, Brenda Miller of the Hartford History Center of the Hartford Public Library and Beth Burgess of the Harriet Beecher Stowe Center.

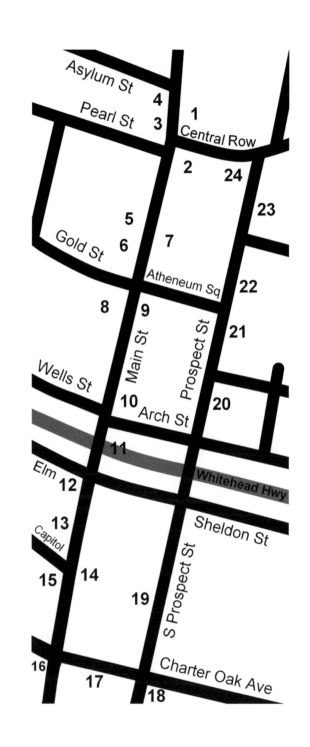

TOUR 1
Downtown South

Downtown is where Hartford's earliest English colonial settlement was focused. With rapid development occurring in the nineteenth and early twentieth centuries, the area was in a state of continuous change. New buildings frequently replaced earlier ones. Because of this, little survives today from the colonial era. Modern urban renewal projects have also resulted in the destruction of numerous older buildings. While much has been lost, there are also many landmarks remaining that attest to the achievements of the city's most prosperous period in the nineteenth and early twentieth centuries.

This tour starts in the area around the Old State House, which was the center of early Hartford. It then continues south on Main Street, where some of the city's most historic sites are located, and returns north on Prospect Street, which was once a residential area.

1. The Old State House
800 Main Street

Hartford, like other New England settlements, was founded by Puritans from England. The land where the Old State House now stands was where the community's first meetinghouse was built in 1636. Soon replaced by

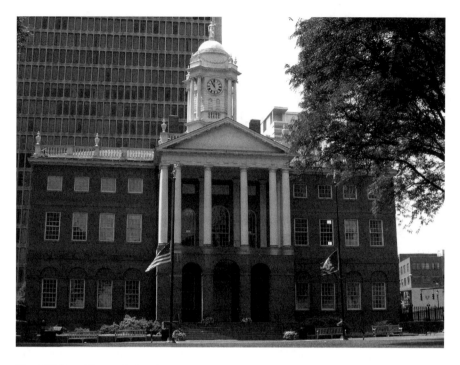

The Old State House. *Author photo.*

a larger building, the meetinghouse was both a house of worship and the seat of town government. Momentous events in Hartford's early history occurred here, including the ratification of the Fundamental Orders in 1639 and the stealing of the charter from Governor Andros in 1687. Hartford's commercial life was jump-started in 1643 when a weekly market began to be held on the southeast corner of Meetinghouse Yard. In 1647, Alse Young, the first person to be executed for witchcraft in the American colonies, was hanged on the future site of the Old State House.

Changes to the buildings on Meetinghouse Square came in the eighteenth century. In 1720, Connecticut's first statehouse, constructed of wood, was built here. In 1739, the location of the meetinghouse was changed to a corner of the Ancient Burying Ground, south of here.

During the Revolutionary War, an important meeting took place in front of the statehouse. On September 20, 1780, General Jean-Baptiste Donatien de Vimeur, comte de Rochambeau, arrived at the ferry landing after crossing the Connecticut River. Greeted by a thirteen-gun salute from the Governor's Guard, Rochambeau and his party were watched by crowds of onlookers as he

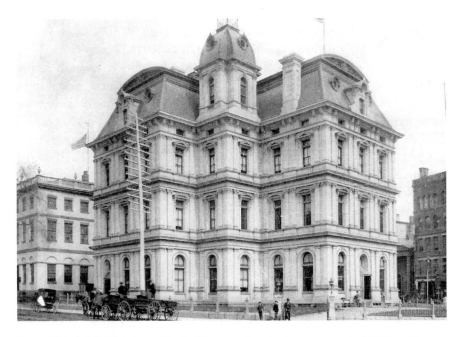

From 1872 to 1934, this post office building stood on the lawn next to the Old State House, which can be seen to the left. *Tomas Nenortas.*

made his way to the front of the statehouse to meet General George Washington. Rochambeau's French army had arrived at Newport, and he was meeting with his American ally to plan their joint strategy against the British. They walked several blocks south to Jeremiah Wadsworth's house (where the Wadsworth Atheneum is today) for their important discussions. Their conference was cut short by the news of a British naval buildup, but the following year, the two generals met again at the Joseph Webb House in Wethersfield, just south of Hartford. There they continued making plans for the campaign that would end a few months later with victory at Yorktown in October 1781.

The 1720 statehouse was damaged by fire in 1783, leading to the decision to construct a new building. What is today called the Old State House was completed in 1796 to plans sent from Boston by the famed architect Charles Bulfinch. Some of the building's most notable architectural features were actually added later, including the wooden roofline balustrade in 1815 and the cupola with a figure of Justice in 1827. The building housed the state assembly (which alternated with the statehouse in New Haven) and the Connecticut Supreme Court. Many famous events took place in this building, including the Hartford Convention of 1815 and the first *Amistad*

trial in 1839. After the current state capitol was built, the Old State House was used as Hartford's city hall from 1878 to 1915. Later saved from demolition by a group of concerned citizens, the building is now a museum.

When the Old State House was built, space was allocated on the third floor to Joseph Steward, a portrait painter and congregational minister. To draw in more people to see his paintings, Steward opened the Museum of Natural and Other Curiosities in 1797. His collection, which included such exhibits as a two-headed calf as well as man-made curiosities, outgrew the statehouse in 1808 and moved to a house on the corner of Main and Talcott Streets. After his death, it was relocated to Central Row and continued for many years. The museum has been re-created and can be visited inside the Old State House.

Instead of facing Main Street, the Old State House faces east, toward the Connecticut River, reflecting how vital the river was to the city's economy at the time. The arrival of the railroad later shifted focus to the west, and the Main Street side became the entrance to the building. On what is now the east lawn of the Old State House, a large Second Empire–style post office building was built in 1872–78 and was expanded in 1905. Towering over the Old State House and blocking what was once its front side, the post office was finally demolished in 1934 and the lawn restored.

Look at the buildings on Central Row, facing the Old State House on the south.

2. Central Row

Between two skyscrapers of the 1920s stands a survivor of an earlier era of Hartford architecture, the Putnam Building, at 6 Central Row, built in about 1860. Italianate brownstone commercial structures like the Putnam were very popular in Hartford in the middle decades of the nineteenth century, but few survive today. Among the Putnam's vanished neighbors was the Hungerford & Cone Building at the corner of Central Row and Main Street that was considered one of the most impressive structures in the city when its brownstone façade was completed in 1856. It was purchased by the Hartford Trust Company in 1869. After that company merged with the Connecticut Trust Company in 1919, it built the current skyscraper on the site, at 750 Main Street and 2 Central Row, in 1921. Designed by Morris & O'Connor of New York, the building's Neoclassical architecture is a clear nod to its

venerable neighbor, the Old State House. A similarly respectful approach was taken in the design of the other skyscraper, the Travelers Insurance Building at 9 Central Row, designed by Voorhees, Gmelin & Walker of New York and completed in 1928.

Facing the Old State House across Main Street are two quite different twentieth-century buildings.

3. Hartford National Bank
777 Main Street

The block of Main Street between Pearl Street and Asylum Street is dominated by a modern twenty-six-floor office tower designed by Welton Becket and Associates of New York. It was built between 1964 and 1967 as the headquarters of the Hartford National Bank, the city's oldest bank, which had its origins on this very same block back in 1792. An advertisement printed in the *Connecticut Courant* of February 27 of that year summoned all interested merchants to a meeting that evening at "Mr. David Bull's," to discuss a plan to petition the General Assembly to establish a bank in the city. Located at about the center of this block, Bull's Tavern ("At the Sign of the Bunch of Grapes") was the leading hostelry in Hartford in the later eighteenth century. A bronze plaque on the modern skyscraper, placed by the Daughters of the American Revolution in 1935, commemorates the historic tavern where Hartford banking was born.

The 1960s construction required the demolition of three notable buildings that, by the early twentieth century, had became collectively known as "Bankers' Row." The lot farthest south had once been the location of the 1827 Allyn Hall, later called Union Hall. It was replaced in 1870 by the grand Gilded Age architecture of the Connecticut Mutual Life Insurance Company Building, owned after 1928 by Hartford National Bank & Trust. Next to the north were two successive buildings of the State Bank (1850 and 1908). The third lot, the site of Bull's Tavern, contained four successive versions of the Phoenix National Bank Building. The earliest, built in 1817, was the first marble building in Hartford. The second, which stood from 1874 to 1905, was designed by George Keller, a notable Hartford architect.

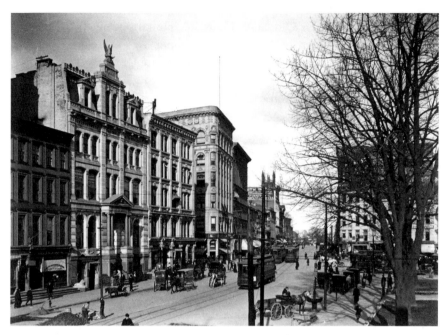

Above: View of Main Street across from the Old State House, 1903. *From left to right*: the 1850 State Bank Building, the 1874 Phoenix National Bank building (designed by George Keller), the circa 1870s Corning Building and the 1898 Catlin Building. All were later demolished. *"Main St. at the Old State House," PG 430, William H. Thompson Photographs, State Archives, Connecticut State Library.*

Left: The Hartford-Aetna Building replaced the Catlin Building (in the previous picture) in 1912. Hartford's first skyscraper, it was demolished in 1990. *Tomas Nenortas.*

4. Corning Building
811 Main Street

Next to the former Hartford National Bank building is the Corning Building, built in 1928–30. It replaced an earlier Corning Building, dating to the 1870s. The building before that was the three-story Robinson and Corning Building, dating to the 1820s. For many years in the mid-nineteenth century, Flavius A. Brown ran a bookstore here (Brown & Gross) that was patronized by such Hartford luminaries as Reverend Horace Bushnell and author Harriet Beecher Stowe. Arriving by train to deliver a speech in Hartford on March 5, 1860, future president Abraham Lincoln walked up Asylum Street to the bookstore, where he first met Gideon Welles, the editor of the *Hartford Evening Press*. Welles would later serve as Lincoln's secretary of the navy.

Dr. Horace Wells, a dentist, once had his office on the second floor. In 1844, an important moment in medical history took place there: the first administration of anesthesia for the purpose of relieving pain. On December 10, 1844, Dr. Wells had attended an exhibition of nitrous oxide, known as laughing gas, at nearby Union Hall (such shows were popular entertainments at the time). There he observed a man under the influence of nitrous oxide. The man had acted wildly, not realizing he had badly scraped his own legs until the effects of the gas had worn off. Inspired by this, the following day, Dr. Wells had a tooth successfully removed without pain after first inhaling the gas. Unfortunately, he was not successful in capitalizing on his discovery. A demonstration he gave at the Massachusetts General Hospital in Boston in 1845 became a fiasco after the gas was inadequately administered to the volunteer patient.

Later, Dr. William Morton, a physician and former apprentice of Wells's, successfully patented his own rival anesthetic based on ether. Dejected, Wells continued his own experiments, becoming addicted to chloroform in the process. Becoming increasingly deranged, Wells was arrested in New York City after throwing acid on two prostitutes. Imprisoned, he committed suicide by cutting an artery in his leg (having first inhaled a dose of chloroform to blot out the pain). A plaque was placed on the Corning Building in 1894 to honor Wells on the fiftieth anniversary of his discovery.

Hartford's first skyscraper once stood where there is now a parking lot at the intersection of Main and Asylum Streets. The Hartford-Aetna Building, designed by Donn Barber and built in 1912, was demolished in 1990.

Head south on Main Street. The building on the right, at the southwest corner of Main and Pearl Streets, is the Gold Building, built in 1975. Next to it is Hartford's oldest cemetery.

5. Ancient Burying Ground
60 Gold Street

In use from 1640 to 1803, the Ancient Burying Ground was once much larger, but the construction of buildings around it, including the First Congregational Church, has reduced its area to four acres. It is believed that about six thousand people were buried here, but many were not given gravestones when they were interred and other gravestones have disappeared over time. Only about 415 stones remain standing today. In 1896, the grounds were surrounded by a wrought-iron fence designed by McKim, Mead & White.

Important figures in Hartford's history who are buried here include Reverend Thomas Hooker and Jeremiah Wadsworth. Among the monuments at the burying ground is an obelisk inscribed with the names of the founders of Hartford. There is also a memorial commemorating the African Americans interred here. This includes 63 known interments and 250 others believed to lie here. A statue of Reverend Samuel Stone, who is also buried here, stands outside the grounds. Reverend Stone, who was Thomas Hooker's assistant minister, negotiated the purchase of land from the Sukiaug tribe and named the new settlement after his birthplace, Hertford in England.

6. Center Church
675 Main Street

The First Church of Christ in Hartford, known as Center Church, was built here in 1807. It replaced a previous meetinghouse of the church, constructed here in 1739. The current church's ornate Federal-style steeple is said to have been designed by Daniel Wadsworth, founder of the Wadsworth Atheneum. The church has several Tiffany stained-glass windows.

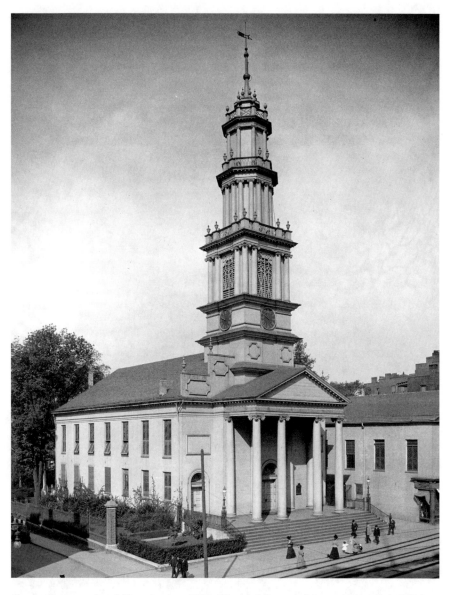

Center Congregational Church, circa 1907. *Library of Congress, Prints and Photographs Division, Detroit Publishing Company Collection.*

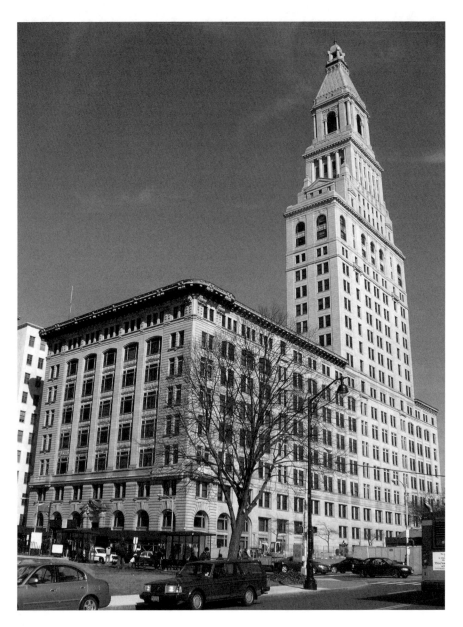

Travelers Tower. *Author photo.*

Gold Street, on the south side of Center Church and the Ancient Burying Ground, is an early example of urban renewal. By the late nineteenth century, Gold Street was a narrow track lined with stables and tenements. In the 1890s, Emily Seymour Goodwin Holcombe, regent of the Ruth Wyllys Chapter of the Daughters of the American Revolution, led the effort to clear away the slums and broaden the street. The north side of Gold Street is now the location of artist Carl Andre's *Stone Field Sculpture*. Installed in 1977, it consists of thirty-six uncut glacial boulders.

7. Travelers Tower
1 Tower Square

Across Main Street from Center Church and the Ancient Burying Ground is the headquarters building of Travelers Insurance Company, which was founded in Hartford in 1863. The building, designed by Donn Barber of New York, was constructed in stages. The first two sections were built facing Main Street in 1906 and 1912. The 527-foot tower, one of Hartford's most recognizable landmarks, was the tallest building in New England and the seventh tallest in the world when it was completed in 1919. In 1963, several earlier buildings facing the Wadsworth Atheneum were removed to create a new grand entrance plaza, facing south.

8. Bushnell Plaza

On south side of Gold Street, across from Center Church and the Ancient Burying Ground, is Bushnell Plaza, an elevated expanse of concrete. Conceived in the 1960s by I.M. Pei, Bushnell Plaza consists of an underground garage and basement shops that face inward and are hidden from Main Street. Above is a barren terrace that has been unused for decades. Adjacent to the plaza is Bushnell Tower, an apartment building built in 1969 and also designed by Pei.

9. Wadsworth Atheneum
600 Main Street

The Wadsworth Atheneum Museum of Art is the oldest public art museum in the United States. It was founded in 1842 by Daniel Wadsworth, a prominent patron of the arts. The castle-like Atheneum building, designed by Ithiel Town and Alexander Jackson Davis, was completed in 1844. At one time, it housed not only an art museum but also the Connecticut Historical Society, the Young Men's Institute (now the Hartford Public Library), the Natural History Society and the Watkinson Library (now at Trinity College). The Atheneum was built on the site of the old Wadsworth House, residence of Daniel Wadsworth's father, the wealthy merchant Jeremiah Wadsworth, who had hosted Washington and Rochambeau in 1780. Nearby stood the Wadsworth Stable, an ornate structure that was saved from demolition and moved to Lebanon, Connecticut, in 1954.

Wadsworth Atheneum, circa 1907. *Library of Congress, Prints and Photographs Division, Detroit Publishing Company Collection.*

The Wadsworth Atheneum has expanded over the years so that the museum today consists of several interconnected buildings. Benjamin Wistar Morris designed two additions, the Tudor Revival Colt Memorial of 1906 and the Neoclassical Revival Morgan Memorial of 1910. Behind the 1844 building is a modernist structure, the Avery Memorial of 1934—the first American museum building to have an International-style interior. The museum has a notable collection that includes old master paintings, Hudson River School landscapes, surrealist works and the Wallace Nutting Collection of American colonial furniture and decorative arts.

In front of the Atheneum's Colt Memorial wing stands a statue of Nathan Hale, Connecticut's state hero, who was captured by the British during the Revolutionary War and executed as a spy in 1776. The statue was created by Enoch Woods Smith as a contest entry in the 1880s for a statue to be placed in the state capitol. It was not selected, but James J. Goodwin, who had commissioned it, later donated it to the museum in 1892.

Between the Atheneum and the Municipal Building is the Alfred E. Burr Memorial, also known as the Burr Mall. It honors the publisher of the *Hartford Times*, who died in 1900. His daughter, Ella Burr McManus, had left funds for its construction, stipulating that it be a drinking fountain for both humans and animals. By the time the funds became available in 1923, horses were being replaced by automobiles on city streets. It was not until the 1960s that a probate judge approved the current design. Burr Mall was completed in 1973 and features Alexander Calder's sculpture *Stegosaurus*.

10. Municipal Building
550 Main Street

Across Burr Mall from the Atheneum is Hartford's Municipal Building (city hall). In 1915, when this building opened, it replaced the Old State House as city hall. Designed by Davis & Brooks, the Municipal Building has a Beaux Arts exterior that is complemented by its interior, a majestic three-story central atrium with panels depicting scenes from Hartford's history.

The entrance on the south side of the building, facing Arch Street, is guarded by two stone lions. They once stood on Main Street, across

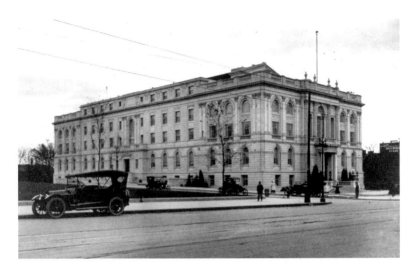

Municipal Building. *Tomas Nenortas.*

from the Old State House. There they were first placed on the roofs of two wings that were added to the Phoenix National Bank in 1827. The lions were next moved to the sidewalk in front of the bank when it was rebuilt in 1873. There they remained until 1918, when a city inspector decided that they were encroaching on the street line and ordered them removed. Thus they came to a new home, keeping a watchful eye on Arch Street.

11. Hartford Public Library
500 Main Street

On the southeast corner of Main and Arch Streets is the Hartford Public Library. Its forerunner was the Hartford Library Company, founded in 1774. The company joined with the Young Men's Institute in 1838 and was located in the Wadsworth Atheneum from 1844 to 1957, when it moved into this new building. On the third floor of the recently remodeled library is the Hartford History Center, which has a collection of more than fifty thousand items, and ArtWalk, an art exhibition space overlooking Main Street.

The library was built over the Whitehead Highway, which passes under Main Street. The highway follows the former bed of the Park River, which now flows through an underground conduit. A stone bridge, which carried Main Street across the Park River, was built in 1833. At the time, it was a notable feat of engineering, being the largest stone arch bridge in the country. The bridge's iron railing can be seen from Main Street. The west side of the bridge can be seen by travelers on the highway, but the east side is now obscured from view.

Continue south on Main Street to the building at the southwest corner of Main and Elm Streets.

12. Central Baptist Church
457 Main Street

In the 1920s, two Baptist churches on Main Street united to form the Central Baptist Church. The First Baptist Church, at Main and Talcott Streets, merged with the South Baptist Church, located here. Built in 1854, the South Baptist Church was demolished to make way for this new Central Baptist Church. It was designed by Isaac A. Allen Jr. and completed in 1926.

Continue south on Main Street to the next building on the right, on the corner of Linden Place.

13. The Linden
1 Linden Place

The Linden is an apartment building built in 1891 by Frank Brown and James Thomson, owners of the Brown, Thompson & Company department store. It was designed by Frederick S. Newman and has an 1895 yellow-brick addition, designed by John J. Dwyer. Attached to the Linden on Linden Place is a block of town houses, also built in 1891 and designed by Newman.

Continue to where Capitol Avenue intersects with Main Street.

14. Butler-McCook House
396 Main Street

Facing Capitol Avenue is the oldest surviving house on Main Street. It was built in 1792 for Dr. Daniel Butler. He had a medical practice and managed the mills that his wife, Sarah Sheldon Ledyard, had inherited from her first husband. Their son, John, and his wife, Eliza Lydia Royce Sheldon, added the Greek Revival portico to the front of the house. In 1865, John and Eliza's daughter, Eliza Sheldon Butler, hired landscape architect Jacob Weidenmann to design the garden that can still be visited behind the house. The next year, she married John James McCook, who served as a chaplain in the Civil War and was one of the famous "Fighting McCooks" of Ohio. For sixty years, Reverend McCook was volunteer rector of Saint John's Episcopal Church in East Hartford, and he later taught at Trinity College. He also studied the plight of homeless people and became a reformer.

In the later nineteenth century, Main Street was rapidly changing from a residential street lined with houses to a commercial area. Rather than move out, as so many others were doing at the time, the McCooks remained. In 1897, Reverend and Mrs. McCook's son, John, a doctor, added an office to the house for his medical practice. His sister, Francis A. McCook, was the last of the family to live in the house. When she died in 1971, she left it to what is now Connecticut Landmarks. The Butler-McCook House & Garden is now open to the public as a museum. The former doctor's office is now the Main Street History Center.

Continue south on Main Street to the next building on the right, on the southwest corner of Capitol Avenue.

15. Hotel Capitol
389 Main Street

A High Victorian building, the Hotel Capitol was built in 1874 by John W. Gilbert. After 1905, it was successfully run by Isidore Wise as a residential hotel. The next building south of the Hotel Capitol is the McKone block, built in 1875.

Continue on Main Street to the church on the right.

16. South Church
277 Main Street

The Second Congregational Church was organized in 1670, following years of doctrinal disputes in the Hartford church following the death of Thomas Hooker in 1647. The new congregation built its first meetinghouse in 1673, later replaced by its second in 1754 and then this church, built in 1827. Known as South Church, it has a less elaborate spire than that of Center Church, built two decades earlier. The interior has a shallow ceiling dome installed by Minard Lafever in 1853.

Turn left on Charter Oak Avenue and walk to the former synagogue, on the right.

17. Charter Oak Cultural Center
21 Charter Oak Avenue

This building was originally Temple Beth Israel, the first synagogue to be constructed in Connecticut. Designed by George Keller, it was built in 1876 and enlarged in 1898. Congregation Beth Israel, established in 1843, moved to West Hartford in 1936. The former synagogue was then home to Calvary Baptist Church until 1972 and then was restored to become the Charter Oak Cultural Center, a secular multicultural arts center, in 1979.

Continue on Charter Oak Avenue to the monument, located where Charter Oak Place makes a sharp turn up the hill on the right.

18. Charter Oak Monument

In 1687, Edmund Andros arrived in Hartford with an armed force. He had been appointed by King James II as royal governor of the "Dominion of New England," which combined all of the New England colonies under his rule. Andros was determined to take possession of Connecticut's

The Charter Oak. *Memorial History of Hartford County, 1886.*

Royal Charter of 1662. According to legend, at an evening meeting with the colony's leaders, the candles suddenly went out, and when they were relighted, the charter had vanished. Captain Joseph Wadsworth had whisked it away and hid it in the hollow of an old oak tree on the Wyllys estate. After Andros was overthrown by the Boston revolt in 1689, the charter was brought out of concealment, and Connecticut was again governed as an independent colony.

What became known as the Charter Oak was a Hartford landmark until it was toppled by a storm in 1856, but it continues as a symbol of Connecticut. The apartment building on the hill here was built on the site of the famous Charter Oak. The nearby memorial, designed by Charles Adams Platt, was placed here in 1907 by the Connecticut Society of Colonial Wars.

From Charter Oak Avenue, turn left to head back north on South Prospect Street. On the left is a brick gambrel-roofed house.

19. Amos Bull House
63 South Prospect Street

Originally located on Main Street, this house was built in 1788 for Amos Bull. He was a dry goods merchant who had a shop on the first floor and also ran a school in the house, which he eventually sold in 1821. The house was moved in 1940 and again in 1971 to its present location on South Prospect Street, behind the Butler-McCook House.

Continue north on Prospect Street, passing the rear of the Abraham Ribicoff Federal Building, the Hartford Public Library and the Municipal Building. After the intersection with Arch Street, there is a large building on the right that, appropriately, faces the Burr Memorial.

20. Hartford Times Building
10 Prospect Street

The *Hartford Times* newspaper ran from 1817 to 1976. This building, designed by Donn Barber, was constructed in 1920 and reused six Ionic green granite columns, which were saved from the 1919 demolition of the Stanford White–designed Madison Square Presbyterian Church in New York. The building's porch terrace was once a popular spot for presidential campaign speeches. The walls under the portico have allegorical panels painted by Ralph Calder.

Continue north on Prospect Street, which was once lined with fine residences, including the house of Daniel Wadsworth. Proceed to the next building on the right.

21. Hartford B.P.O. Elks Lodge no. 19
34 Prospect Street

The Hartford Elks Lodge was organized in 1884, and this building, designed by John J. Dwyer, was built in 1903. Continue on Prospect Street to the building that faces the entrance plaza of Travelers Tower.

22. The Hartford Club
46 Prospect Street

The Hartford Club was founded in 1873 as a union of several local clubs and soon developed a reputation as a literary club. Samuel Clemens (Mark Twain) joined in 1881. By the turn of the century, the club was focused on serving the political and business community of the state. In its early decades, the Hartford Club rented a series of increasingly larger spaces on Prospect Street. After merging with the Colonial Club in 1901, this building was constructed in 1903. Designed by Robert D. Andrews, it was opened in 1904.

Continue north on Prospect Street, past the intersection with Grove Street. Down Grove Street once stood the Barnabas Deane House, one of Hartford's lost architectural treasures. It was designed and built in 1780 by William Sprats, a master builder of the Federal period. Barnabas Deane was a merchant and the brother of the Revolutionary War–era diplomat Silas Deane, whose own house still stands in nearby Wethersfield, Connecticut.

23. Hartford Steam Boiler Inspection and Insurance Company
56 Prospect Street

In 1857, several Hartford businessmen formed the Polytechnic Club to discuss current scientific and technical issues. In the 1850s, steam boiler explosions were common, with one occurring almost every four days. The club members discussed a new idea of combining insurance with regular boiler safety inspection. Based on this concept, the Hartford Steam Boiler Inspection and Insurance Company was founded in 1866. The company's building here, designed in the Art Deco style by Carl J. Malmfeldt, was built in 1932.

Continue on Prospect Street to the building on the left, at the corner of Central Row. Those who are walking this tour can turn left to see the front of the building, but cars can't turn left here.

24. Marble Pillar
19–25 Central Row

The two-story commercial building on the corner was built in 1939 by Travelers. The Art Deco structure, designed by Smith & Bassette, takes its name from a former tenant, the Marble Pillar Restaurant. A popular meeting place for Hartford's political and business leaders, the restaurant was in business from 1860 to 1993.

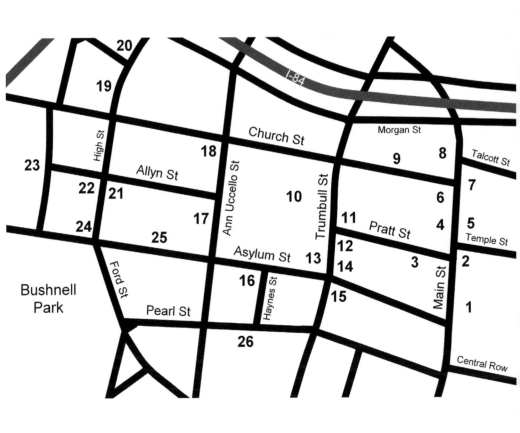

Downtown North and West

A s in the previous tour, this one starts at the Old State House, but instead of heading south, it heads north and west, ending at Union Station.

1. State House Square

The pedestrian-only area north of the Old State House was once the continuation of State Street, which intersected here with Main Street. Many interesting buildings have come and gone on this block, including the old United States Hotel, the 1834 Greek Revival building of the Hartford National Bank and the 1880 Courant Building, designed by George Keller. The legendary Honiss Oyster House was in operation on this block of State Street from 1845 to 1982. This entire stretch is now taken up by State House Square, an office and retail complex completed in 1987. Designed by Russell Gibson von Dohlen, the structure incorporates the 1899 Beaux Arts façade of the former First National Bank building, designed by Ernest Flagg.

Continue north on Main Street to the building on the right that faces Pratt Street, at the southeast corner of Main Street and Temple Street.

The 1880 *Hartford Courant* building, designed by George Keller; it was later demolished. *Memorial History of Hartford County, 1886.*

2. Sage-Allen Building (Lofts at Main and Temple)
884 Main Street and 21 Temple Street

Another classic façade that has been preserved as part of a contemporary structure is that of the old Sage-Allen Department Store. Established in 1889 at the corner of Main and Pratt, Sage-Allen constructed its building here in 1898. The successful business later incorporated several adjacent buildings into its expanding store. The company declined in the 1980s and finally ceased operations in 1994. The old building was converted into new retail and apartment space in 2006, with new infill construction on either side devised to not clash with architect Isaac A. Allen Jr.'s original Renaissance Revival embellishment.

Cross Main Street and walk down Pratt Street to the building located just past the parking lot on the left.

View of Main Street in 1904. The 1898 Sage-Allen Building is in the center of the block. *"Main St. East Side," PG 430, William H. Thompson Photographs, State Archives, Connecticut State Library*.

3. Society for Savings
31 Pratt Street

Organized in 1819, Society for Savings was Connecticut's first mutual savings bank. It moved to this site in 1834, and the current building was constructed in 1893. Unfortunately, the building's exterior has lost much of its Renaissance Revival detailing through later alterations, but the ornate interior, created in 1926, retains its original magnificence. After Society for Savings merged with another bank in 1993, the building remained closed for more than a decade. Now it is a glamorous banqueting facility called the Society Room.

Return to Main Street and continue north to the next large building on the corner of Pratt and Main Streets.

4. One American Plaza
915 Main Street

Wise, Smith & Company, which advertised itself as "Connecticut's Greatest and most Progressive Department Store," occupied this building into the 1950s. Established in 1897, the company expanded rapidly under the direction of Isidore Wise (1866–1956). Starting with its original six-story building, which had grown to nine stories by 1912, the company built an addition on Pratt Street and took over the neighboring Roberts Opera House on Main Street. The expansion culminated in 1929, when the current building was completed. It combined the earlier building with a newly built section to create a large, unified structure. Later known as the American Airlines Building, it has recently been converted into new retail and apartment space. Some of the building's long hidden Art Deco details have recently been rediscovered.

Look at the much older building directly across Main Street.

5. Richardson Building
942 Main Street

Henry Hobson Richardson (1838–1886) is recognized as one of America's greatest architects. His distinctive style, featuring thick stone walls with dramatic round-headed arches, is known as Richardsonian Romanesque. This building was designed by Richardson for two brothers from the Cheney silk manufacturing family of Manchester, Connecticut. When it was completed in 1876, the Cheney Building had a pyramidal roof, since removed, on the southwest corner tower. For many years, the building was home to the Brown, Thompson & Company Department Store. Now known as the Richardson Building, it has a long history of containing retail, office, residential and, more recently, hotel space.

Continue north on Main Street to the church on the left.

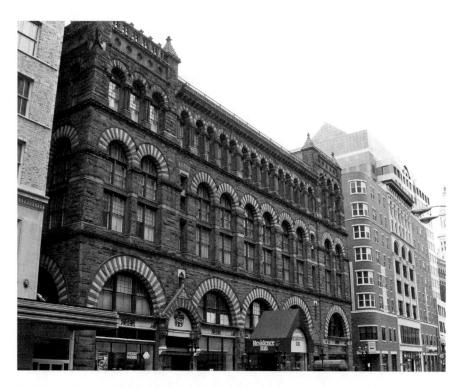

The Richardson (or Cheney) Building. Designed by H.H. Richardson. *Author photo.*

6. Christ Church Cathedral
45 Church Street

Christ Church, which since 1919 has been the cathedral of the Episcopal Diocese of Connecticut, is one of the oldest Gothic Revival–style buildings in the United States. It was built in 1827–29 to the designs of Ithiel Town of New Haven, who had earlier designed that city's Trinity Episcopal Church, built in 1814.

Christ Church Cathedral, as we see it today, was completed in several stages. The bell tower, designed by Henry Austin of New Haven, was built in 1839. In 1879, Frederick C. Withers designed the Parish House and the recessed chancel, which added an additional sixteen feet to the cathedral's original length of one hundred feet. George Keller made alterations in 1903, and Ralph Adams Cram designed the Chapel of the Nativity in 1907.

Look at the large building across Main Street, to the left of the Richardson Building.

7. G. Fox Building
960 Main Street

G. Fox & Company was long the city's most prominent department store. Founded in 1847 by Gerson Fox, the store was expanded by Gerson's son, Moses Fox. In 1917, a devastating fire destroyed the earlier G. Fox store on this site. In its place rose this eleven-story building, designed by architect Cass Gilbert, the leading master of the Neoclassical Revival style. When Moses Fox died in 1938, his daughter, Beatrice Fox Auerbach (1887–1968), became president of the company. Under her leadership, G. Fox became one of New England's most successful department stores and the largest privately held store in the nation. She was highly respected for her innovative sales practices, high standard of customer service and pioneering workplace reforms, as well as her civic leadership and philanthropy.

This grand department store closed its doors in 1993 but, a decade later, found new use as the home of Capitol Community College.

Look at the modern building on the corner of Main and Church Streets.

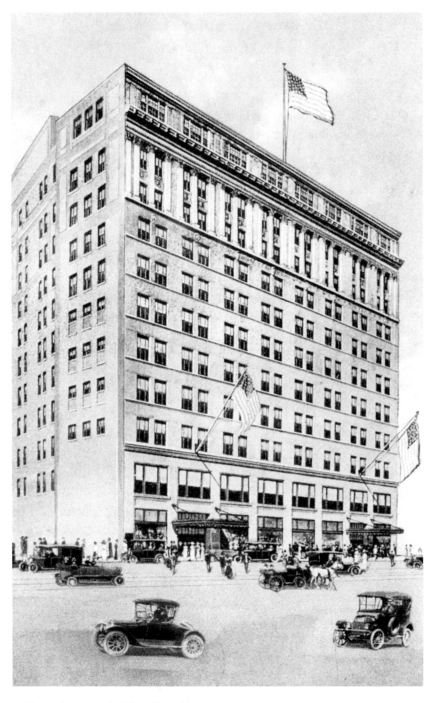

G. Fox & Company Building. *Tomas Nenortas.*

8. One Corporate Center
20 Church Street

Known as the "Stilts Building," this distinctive office structure by Irwin Joseph Hirsch & Associates was built in 1981.

Head west on Church Street.

9. Hartford Stage
50 Church Street

Founded in 1963 by Jacques Cartier, Hartford Stage has become one of the leading resident theaters in the United States. Starting in a former grocery store warehouse, the theater was moved to this building, designed by Venturi & Rauch, in 1977.

Follow Church Street to Trumbull Street and turn left. The XL Center dominates the area on the west side of Trumbull.

10. XL Center
1 Civic Center Plaza

Opened in 1975, the Hartford Civic Center, designed by Vincent G. Kling & Associates, occupies four blocks and originally consisted of the Veterans Memorial Coliseum and Exhibition Center, a shopping mall and an attached hotel. On January 18, 1978, at 4:15 a.m., the roof of the Civic Center arena collapsed into rubble from an accumulation of snow and ice, crushing the seats below. Amazingly, no one was killed, but it could have been a major disaster—just hours before, the arena had been filled with fans watching a men's basketball game (UConn versus UMass). The rebuilt arena opened again in 1980.

The New England Whalers, members of the World Hockey Association, came to Hartford in 1974 and in 1979 joined the National Hockey League as the Hartford Whalers. The Civic Center remained the team's home until 1997, when it moved to Raleigh, North Carolina, and became the Carolina Hurricanes.

A portion of Civic Center's mall was demolished in 2004 and replaced by Hartford 21. In 2007, the building was renamed the XL Center.

Head south on Trumbull Street. Just before Pratt Street, on the left, is the Standard Building.

11. Standard Building
228–260 Trumbull Street

Originally completed in 1926, the Standard Building was designed by Buck & Sheldon. The structure's height was doubled in 1988.

An arch marks the beginning of Pratt Street, with the old Sage-Allen building on Main Street visible at the other end. Only one block long, Pratt Street began as a residential street in the early nineteenth century. The Hartford Female Seminary, a school for girls founded by Catherine Beecher in 1823, moved to Pratt Street in 1827. That same year, Catherine's younger sister, Harriet Beecher Stowe, was a teacher at the school. The seminary building does not survive, but many late nineteenth and early twentieth-century commercial buildings still line this block.

12. Steiger Building
99 Pratt Street

Albert Steiger of Steiger's Department Stores constructed two buildings in Hartford in the 1920s. The first was built in 1920–21 at the other end of Pratt Street, where the parking lot next to the old Society for Savings building is today. The other is this building, at the southeast corner of Trumbull and Pratt Streets. Built in 1926–28, it was designed by Smith & Bassette to correspond in architecture and building materials with the earlier Steiger Store.

Next to the Steiger Building, at 196 Trumbull Street, is the Heublein Building, built in 1896. It was originally the home of G.F. Heublein and Brothers, a liquor and wine company that created the world's first bottled cocktails in 1892 and brought A1 Steak Sauce to the United States in 1895.

The eighteenth-century house of Dr. Norman Morrison was demolished to make way for the Heublein Building. Born in Scotland, Dr. Morrison (1690–1761) settled in Hartford in about 1740. He is credited with being the first man to separate the practice of medicine from pharmacy.

Look at the tall building across the street, located at the northwest corner of Trumbull and Asylum Streets.

13. Hartford 21
221 Trumbull Street

Replacing the old Civic Center mall, Hartford 21, a thirty-six-story luxury apartment tower, was completed in 2006. This corner was once the location of the Allyn House, which was the finest hotel in Hartford when it was opened

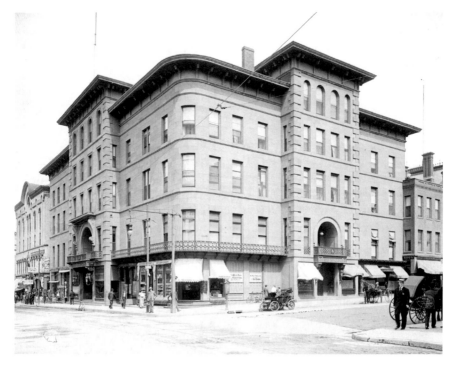

Allyn House Hotel, circa 1908. This 1857 building was demolished in 1960. *Library of Congress, Prints and Photographs Division, Detroit Publishing Company Collection.*

in 1857. Designed by Octavius Jordan, the elegant Italianate building (where Abraham Lincoln once stayed) was demolished in 1960.

Continuing on the east side of Trumbull Street are two nineteenth-century commercial buildings.

14. Brownstone Building
190 Trumbull Street

The northeast corner of Trumbull and Asylum Streets has had an interesting history. During the presidential election campaign of 1840, local rallies were held here in a log cabin erected by members of the Whig Party. The Whig nominee, William Henry Harrison, had been derided by his Democratic opponents as "the log cabin and hard cider candidate." The Whigs embraced this image and used it to promote Harrison as a representative of the common man.

The Unitarian Church of the Saviour was later built here in 1846. The church building was moved in 1860 to Asylum Hill to be used by Trinity Episcopal Church (see Tour 10). In 1861, the current building here was erected for the Charter Oak Bank. It is one of the few survivors of the many brownstone-faced commercial buildings that were constructed throughout downtown Hartford in the mid-nineteenth century.

15. 105 Asylum Street

Across Asylum Street on the southeast corner with Trumbull Street is a building constructed in about 1855 by Timothy Allyn, proprietor of the Allyn House. In 1896, the building housed Willis & Wilson, a clothing store, whose owners commissioned the architect Isaac A. Allen Jr. to design a new two-story cast-iron front for the building. Manufactured by the George S. Lincoln Company, the intricately designed front, with broad display windows, has been a Hartford landmark ever since. From 1909 to 1989, the building was home to Willis and Wilson's successors, Stackpole, Moore & Tryon, a clothing store that has since moved to the

Standard Building. The building continues to be owned by descendants of the Allyn family.

Head west on Asylum Street to the ornate building at the corner of Haynes Street.

16. Goodwin Square
225 Asylum Street

Yet another example of an earlier building's façade preserved as part of a new structure is Goodwin Square, a skyscraper completed in 1989. The original Goodwin Building was built in 1881 as an apartment building by the brothers James J. Goodwin and Francis Goodwin. The architect, Francis Kimball, used ornamental terra cotta to create the Queen Anne edifice, modeled on buildings in the same style that Reverend Francis Goodwin had seen being constructed in England. Expanded in 1891 and 1900, the Goodwin Building's fine interiors were eventually destroyed, with only the historic structure's outside walls surviving to be incorporated into Goodwin Square.

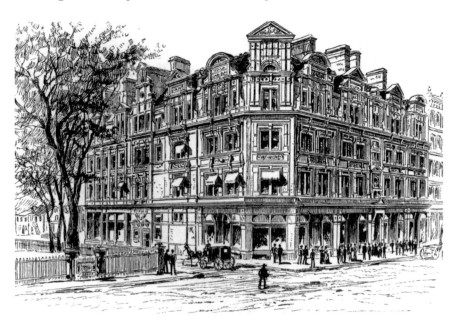

Goodwin Building. *Memorial History of Hartford County, 1886.*

Next to Goodwin Square, at 235–257 Asylum Street, are three buildings erected between 1870 and 1872 by John Harrison. The two on the left are notable for their extensive use of cast iron, a decorative feature most commonly associated with the SoHo Cast Iron District in New York City.

Turn right onto Ann Uccello Street. Ann Street was opened in 1814 by James and Nathaniel Goodwin, who named it after their mother, Ann Sheldon Goodwin. In 2008, it was renamed Ann Uccello Street in honor of Hartford's first female mayor, who served from 1967 to 1971.

17. Masonic Hall
199–203 Ann Uccello Street

Distinctive Moorish architectural features and a variety of Masonic symbols are found on this fascinating building designed by Brooks M. Lincoln and constructed in 1894–95. The Masonic Hall's striking stained-glass windows were later removed, and the building is now used as office space.

Next to the Masonic Hall, at 191 Ann Street, is a landmark of Hartford's nightlife, the Russian Lady. Originally in operation from 1976 to 1997, it has recently reopened under new management. Unable to acquire the original *Mother Russia* sculpture that adorned the building's roof, the new owners commissioned a replica.

Across from the Masonic Hall, at 90–100 Allyn Street, is the Crosthwaite Building. Another building designed by Isaac A. Allen Jr., it was built in 1911 to house the Hartford Wire Works Company. Frederick Crosthwaite was the company's president.

Continue on Ann Uccello Street past Allyn Street and turn left at the intersection with Church Street.

18. St. Patrick and St. Anthony Church
285 Church Street

Built in 1876 to serve an Irish Catholic population, St. Patrick Church was designed by Patrick C. Keely, who also designed the old St. Joseph's

Cathedral and the Asylum Hill Congregational Church (see Tour 10). The steeple was not replaced when the church was restored after a devastating fire in 1956. Two years later, St. Patrick Church merged with St. Anthony Church, which served the Italian American community of Front Street (see Tour 4).

Continue west on Church Street and turn right on High Street.

19. William R. Cotter Federal Building
135 High Street

Built in 1931–32, this federal building originally housed a post office and courthouse and now contains various federal offices. Designed by Malmfeldt, Adams & Prentice, it is constructed of Indiana limestone and Wisconsin black granite and has two aluminum eagles on the roof. In 1982, the building was renamed to honor Congressman William R. Cotter, who represented the First District of Connecticut from 1971 until his death in 1981.

20. First Company Governor's Foot Guard Armory
159 High Street

Organized in October 1771, the First Company Governor's Foot Guard is the oldest military organization in continuous existence in the United States. In 1780, the Foot Guard escorted Washington to his meeting with Rochambeau in Hartford. Built in 1888, the Foot Guard Armory was designed by architect John C. Mead. The building's drill hall, advertised in the 1890s as the largest public hall between New York and Boston, was once one of Hartford's major locations for public entertainment.

If you are walking, turn around and head south on High Street to the intersection with Allyn Street. If you are driving, continue north on High Street and turn right on South Chapel Street. Turn right on Ann Uccello Street and right on Allyn Street.

21. Park Central Hotel Disaster Site
Southeast Corner of Allyn and High Streets

This parking lot is the unmarked site of a nineteenth-century disaster. On February 18, 1889, the Park Central Hotel's boiler exploded, leveling half the building. Two people were killed. The Hotel Hartford, since demolished, was later built here.

The Judd & Root Building is on the corner of Allyn and High Streets.

22. Judd & Root Building
179 Allyn Street

Built in 1883 by Judd & Root, a firm of wool merchants, this Romanesque Revival building was designed by Francis Kimball, who also designed the Goodwin Building and the Katharine Seymour Day House (see Tour 10). The building has a Renaissance Revival–style arcade on the first floor for retail shops. It became known as the Professional Building in the 1920s, when the ground floor housed a pharmacy and a surgical supply company and more than fifty physicians and surgeons had offices above.

Look down Allyn Street, toward the railroad station.

23. Union Station
One Union Place

The arrival of the railway in Hartford in 1839 signaled a shift from the city's earlier focus on the Connecticut River. Development spread west of downtown. A railroad station, an impressive Italianate building with two massive towers, was built here in 1849. Originally, the tracks approached the station on grade level, crossing Asylum Street. Concerns about the possibility of accidents led to the planning, by architect George Keller, of a new station that would have elevated tracks. Designed by Shepley, Rutan & Coolidge, the successor firm to H.H. Richardson, Union Station was completed in

1889 and was partially rebuilt by Frederick W. Mellor of New Haven after a fire in 1914.

From Allyn Street, head south on High Street. At 28 High Street is the Gothic and Romanesque Revival–style Batterson Block, now called the Lewtan Building. It was built in about 1860 by James G. Batterson, who ran a quarrying business called the New England Granite Company. He founded Travelers Insurance in 1863.

24. Capitol Building
410 Asylum Street

Not to be confused with the Connecticut State Capitol building (in Tour 3), the Capitol Building on Asylum Street was constructed in 1926 as a retail and office block. A primary tenant was the newly chartered Capitol National Bank and Trust. The Neoclassical Revival structure was built by two partners, Joseph Ferrigno and Thomas Perrone, and was designed by Thomas W. Lamb. Left vacant in 2007 and in danger of demolition, the building was saved. Now called The Hollander, it has been converted into mixed-income apartments.

In the block of Asylum Street to the east, which is one-way, is a notable hotel.

25. Hotel Bond
338 Asylum Street

Hartford's grandest hotel in the 1920s and 1930s, Hotel Bond was built by Harry S. Bond in two sections, in 1913 and 1921. By the 1950s, the Bond faced competition from the Statler Hotel, opened in 1954 across Asylum Street (and later demolished). In 1965, the Hotel Bond was sold to the Roman Catholic Archdiocese, which used it as the Saint Francis Hospital School of Nursing. The renovated Bond Ballroom was reopened for receptions in 2001, and the rest of the building is again being used as a hotel today.

If you are walking, continue on Asylum Street, turn right on Ann Uccello Street and then left on Pearl Street. If you are driving, head south on Ford Street and turn left onto Pearl Street.

26. Ados Israel Synagogue
215 Pearl Street

Hartford's oldest Orthodox Jewish congregation built Ados Israel Synagogue on Market Street in 1898. When it was demolished to make way for the Constitution Plaza project in 1963 (see Tour 4), the congregation moved to this building, constructed in 1924 for the First Unitarian Society. The synagogue, the last in Hartford, was closed in 1986.

Follow Pearl Street back to Main Street and the Old State House.

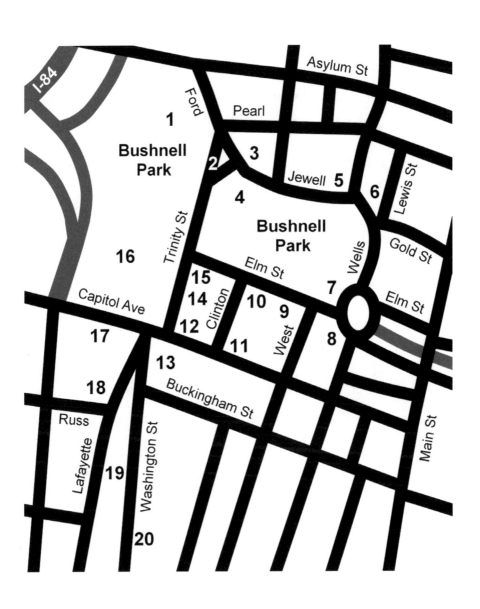

TOUR 3

Bushnell Park and the Capitol Area

B ushnell Park, the oldest publicly funded park in the United States, is the great centerpiece of downtown Hartford. Its creation was spearheaded by Reverend Horace Bushnell (1802–1876), pastor of Hartford's North Church and one of America's leading theologians. Bushnell wanted a green park to replace what was then a slum area, filled with tanneries, pigsties and a garbage dump. The Park River, flowing eastward into the Connecticut River, had become known as the Hog River because it was polluted with industrial and human waste from factories and crowded tenements. Hartford voters approved public expenditure for the park in 1854, and Reverend Bushnell approached Frederick Law Olmsted, the famed landscape architect, to design it. Busy working on New York's Central Park at the time, Olmsted recommended that the city hire Swiss-born Jacob Weidenmann for the job. Weidenmann's 1861 plan created a naturalistic and graceful park that would become an oasis in the midst of a dense urban environment.

The Park River was a central element of Bushnell Park, flowing along its eastern and northern edge. The devastating Flood of 1936 and the Hurricane of 1938 led to the decision to place the river underground, although a pond was later added to restore the presence of water in the park.

Several major insurance companied built their offices near Bushnell Park, and to the southwest stands the Connecticut State Capitol. Trinity College

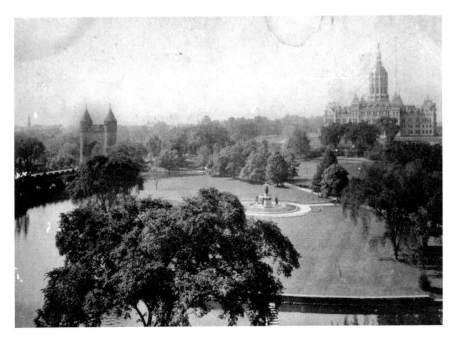

Bushnell Park and the Park River. The Soldiers and Sailors Memorial Arch is on the left, the Corning Fountain is in the center and the state capitol building is on the right. *Tomas Nenortas.*

was once located on this land, but that institution moved to Hartford's South End (see Tour 7) to make way for the 1878 Capitol Building. In time, other imposing state buildings were constructed in the vicinity of the capitol.

The following is a walking tour (parts of this cannot be driven or go against one-way streets) that begins around Bushnell Park, goes on to the buildings near the capitol and then proceeds down Washington Street, which was once lined with fine Victorian-era houses. Begin in the section of Bushnell Park that is south of Asylum Street, adjacent to Ford and Trinity Streets on the east and the highway and train tracks on the west.

1. Corning Fountain

The major landmark in this part of Bushnell Park is Corning Fountain, erected in 1899. It was given to the city by John J. Corning in honor of his father, the merchant John B. Corning. Sculpted by J. Massey Rhind, the

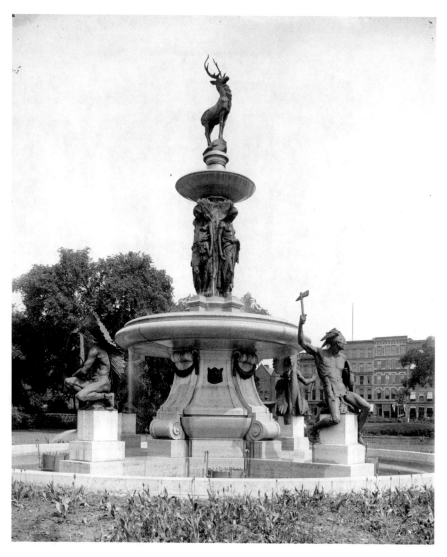

Corning Fountain, circa 1905. *Library of Congress, Prints and Photographs Division, Detroit Publishing Company Collection.*

fountain features four figures of Native Americans and is topped by a hart (stag), the symbol of Hartford.

There are other sculptures in the park. On the west side of Trinity Street is a statue of General Israel Putnam, hero of the Revolutionary War. Close to Elm Street is the Spanish-American War Memorial. Near the pond is a statue of Dr. Horace Wells (see Tour 1).

Lydia Sigourney House, demolished in 1938. *Hartford History Center, Hartford Public Library.*

Beyond the park, on the hill to the west, where there is now a parking lot near Interstate 84, once stood the home of Hartford poet Lydia Huntley Sigourney (1791–1865). Not well known today outside of academic circles, Mrs. Sigourney's work was very popular in the nineteenth century and earned her the title "Sweet Singer of Hartford." Born in Norwich, Connecticut, she came to Hartford to open a school and married the wealthy Charles Sigourney in 1819. The following year, he built the grand house in what was then an undeveloped part of town. Later hemmed in by the train tracks, the house was eventually torn down in 1938.

From Corning Fountain, walk to where Trinity Street bisects Bushnell Park. The street is dominated by an impressive brownstone arch.

2. Soldiers and Sailors Memorial Arch

For its Civil War monument, the City of Hartford chose to construct an arch over a bridge on Trinity Street. It was dedicated on September 17, 1886, the anniversary of the Battle of Antietam. The first permanent triumphal arch in America, the Soldiers and Sailors Memorial Arch was designed

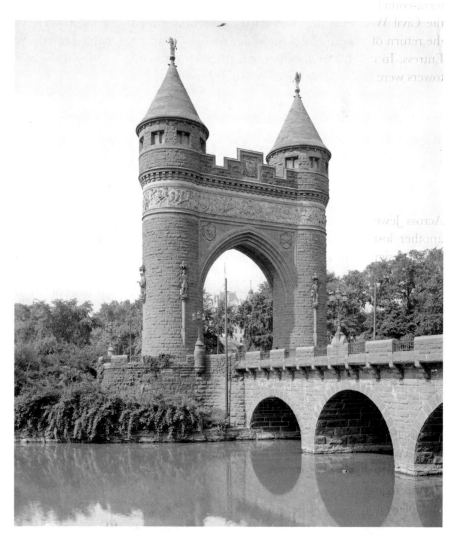

Soldiers and Sailors Memorial Arch and the Park River, circa 1905. *Library of Congress, Prints and Photographs Division, Detroit Publishing Company Collection.*

by Hartford-based architect George Keller. His plan won out over others because of the affordability of his materials, brownstone and terra cotta. The monument combines medieval Gothic towers with two classical friezes. The ashes of Keller, who died in 1935, and his wife, Mary, who died in 1946, are interred in the east tower.

The memorial arch honors the four thousand Hartford citizens who served in the Civil War and the four hundred who died for the Union. The terra-cotta frieze on the north, by Samuel James Kitson, depicts scenes from the Civil War, while the one on the south, by Caspar Buberl, represents the return of peace. The towers have six life-sized figures, carved by Albert Entress. In a 1980s restoration, the original terra-cotta angels on the two towers were replaced with more durable bronze replicas.

3. YMCA
160 Jewell Street

Across Jewell Street from the arch and Bushnell Park is the site of yet another lost landmark of Hartford. The impressive YMCA building of 1893, designed by Edward T. Hapgood, was a distinguished architectural complement to Keller's memorial arch. Adjacent YMCA buildings here were spared, but the great Romanesque Revival edifice was torn down in 1974 for a parking lot.

4. The Carousel

Bushnell Park's carousel was brought here from Canton, Ohio, in 1974. It has a Wurlitzer band organ and forty-eight wooden horses that were hand-carved by Solomon Stein and Harry Goldstein of Brooklyn in 1914.

Walk to Jewell Street, which borders this section of Bushnell Park on the north, and follow it eastward to the tall building on the corner of Trumbull Street.

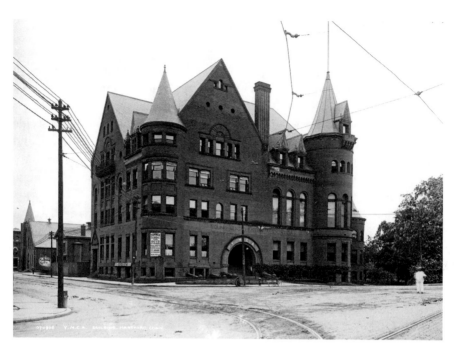

YMCA Building, circa 1900–1910. Built in 1893, this building was demolished in 1974. *Library of Congress, Prints and Photographs Division, Detroit Publishing Company Collection.*

5. 55 On the Park
55 Trumbull Street

This Art Deco building was initially constructed in 1930–31 for the Southern New England Telephone Company. Its original plan, by architect R.W. Foote, anticipated later enlargement, and the upper six floors were eventually added in 1953. The building was later converted into apartments.

Continue to the intersection with Gold Street and turn left onto Lewis Street.

6. Lewis Street

Only one block long, Lewis is the only street in downtown Hartford to have a surviving group of nineteenth-century houses. Those on the east side (nos. 24, 30 and 36) were built by Austin Daniels in about 1840. Lewis Rowell, a builder, constructed the matching pair of houses on the west side (nos. 25 and 27) in 1851 and 1855. Number 25 was his own residence, and the street was named in his honor in 1883. Although these houses have been much altered over the years, Lewis Street still maintains an intimate feel among the surrounding skyscrapers.

Continue south on Wells Street, which curves around the park's eastern edge. At the intersection of Wells Street and Elm Street, across from Pulaski Circle, note the cottage-like building on the edge of Bushnell Park.

7. Pump House Gallery
60 Elm Street

The Pump House was constructed in 1947 by the Army Corps of Engineers using stones salvaged from bridges that once crossed the Park River. The building serves a practical purpose as part of the Connecticut River Flood Control Project, but it also houses a public art gallery.

A series of former insurance company buildings lines Elm Street, starting with one on the corner that faces Pulaski Circle.

8. Connecticut General Life Insurance Company
55 Elm Street

The design for this building, by James Gamble Rogers, was based on the Medici-Riccardi Palace in Florence, Italy. Built in 1926, it was owned by Connecticut General until the company moved to its new headquarters in Bloomfield, Connecticut, an architectural landmark of the International style built in 1954–57.

9. Scottish Union and National Insurance Company
75 Elm Street

The next building west on Elm Street was designed by Edward T. Hapgood and built in 1913. Originally home to the American branch of a Scottish company, it is now used by the Connecticut Appellate Court.

10. Phoenix Mutual Life Insurance Company
79 Elm Street

Also resembling a Florentine palace, this 1920 building, by Morris & O'Connor, was home to Phoenix Mutual Life until the company relocated to the "Boat Building" in 1963 (see Tour 4). Now a state office building, it has an addition on the west side built in 1993 and designed by Smith Edwards Architects to complement the original building.

Turn left on Clinton Street and walk to the church on the corner of Clinton and Capitol Avenue.

11. First Presbyterian Church
136 Capitol Avenue

The First Presbyterian Church of Hartford was formed in 1851 and had several homes until this High Romanesque Revival church was built in 1868–70. It was designed by James Renwick Jr., architect of St. Patrick's Cathedral in New York and the Smithsonian Institution Building in Washington, D.C.

Continue east on Capitol Avenue.

12. The Bushnell Center for the Performing Arts
166 Capitol Avenue

At the corner of Capitol Avenue and Trinity Street is the Bushnell Memorial Hall, which was opened in 1930 as a performance venue and public auditorium. It was the gift of Dotha Bushnell Hillyer in honor of her father, Reverend Horace Bushnell. The exterior of the building was designed in the Georgian Revival style, but the interior is Art Deco. The architectural firm Corbett, Harrison & MacMurray would later work on New York's Rockefeller Center. In recent years, the Bushnell has expanded, adding a new ninety-thousand-square-foot facility in 2001.

13. State Office Building
165 Capitol Avenue

Across from the Bushnell is the large Art Deco–influenced State Office Building, constructed of Indiana limestone in 1931. It was designed by Smith & Bassette.

From Capitol Avenue, turn right onto Trinity Street. On the Trinity Street side of the Bushnell is a statue of Confucius. It was a gift of the Provincial People's Government of Shandong Province, China, in 2006 as part of an exchange of art on the occasion of the twentieth anniversary of Connecticut's sister-state relationship with Shandong. Connecticut had earlier given Shandong a bust of Mark Twain.

Continue north on Trinity Street, where there are two more former insurance buildings.

14. Orient Insurance Company
18–20 Trinity Street

When it was built in 1905, this building had a central dome on the roof that was later removed. Designed by Davis & Brooks, it remains an impressive Beaux Arts structure.

15. Phoenix Insurance Company
30 Trinity Street

Phoenix Fire Insurance Company was founded in 1854. Before moving to this 1917 Georgian Revival building, designed by Morris & O'Connor, the company had been headquartered in an 1873 building on Pearl Street, designed by H.H. Richardson and later demolished.

Walk to the nearby state capitol.

16. Connecticut State Capitol Building

Hartford and New Haven had been alternating as the seat of Connecticut's legislature for 175 years when Hartford won the designation of sole capital in 1875. Plans were made to erect a new statehouse at the western end of Bushnell Park, replacing the Greek Revival buildings of Trinity College, which relocated to a new campus (see Tour 7). Completed in 1878, this is the only High Victorian Gothic-style capitol building in America. The competition for its design was won by Richard M. Upjohn, but he had to make modifications to his plans for the structure in order to please the demanding capitol board commissioners and the contractor for the building, the powerful James G. Batterson. The most notable change was the inclusion of a domed tower, very atypical for a Gothic building. Upjohn had originally envisaged a more traditional clock tower. The project went well over budget because the first dome collapsed during construction.

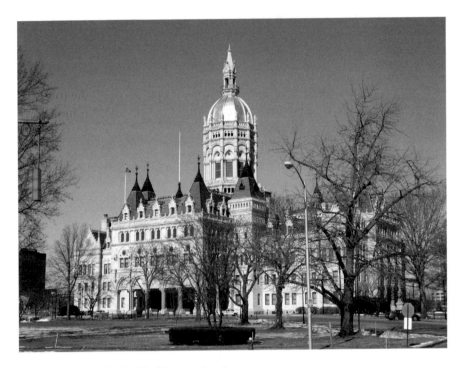

Connecticut State Capitol Building. *Author photo.*

The Genius of Connecticut was a bronze statue that originally stood on top of the capitol dome. It was damaged in the hurricane of 1938 and taken down. During World War II, the statue was donated to the federal government to be melted down for ammunition and machine parts. Fortunately, the original plaster statue, from which the bronze was cast, survived. Painted bronze, it stands in the capitol's north lobby, while under the dome on the first floor is a new bronze cast, made in 2009.

The capitol's façade has niches with statues of important individuals in the state's history. Several niches remain empty for future statues to be added. The most recent addition was placed here in 1987. It is a statue of Ella T. Grasso, Connecticut's first female governor, who served from 1975

to 1980 and died of cancer on February 5, 1981, a little over a month after resigning her office.

Farther down Capitol Avenue to the west is the Legislative Office Building (300 Capitol Avenue), built in 1981 and designed by Russell Gibson von Dohlen. Linked to the capitol grounds by a walkway over the ramp to Interstate 84, the building is notable for its five-story inner atrium. Next door is the massive Connecticut State Armory and Arsenal (360 Broad Street), designed by Benjamin Wistar Morris and completed in 1909.

17. Connecticut State Library and Supreme Court
231 Capitol Avenue

Across from the state capitol is this monumental Beaux Arts building, completed in 1910 to the designs of Donn Barber. The statues above the front entrance, installed in 1913, are figures of Justice, History, Art and Science, sculpted by Michel Louis Tonnetti. The building's eastern wing houses the state library, while the western wing houses the state Supreme

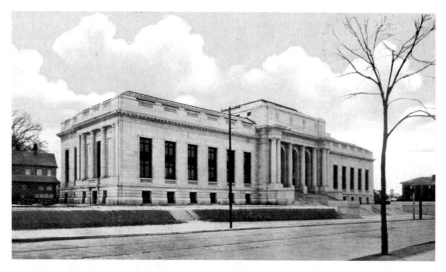

Connecticut State Library and Supreme Court Building. *Tomas Nenortas.*

Court. Between the two wings is Memorial Hall, which is home to the Museum of Connecticut History.

From Capitol Avenue, between the Capitol Building and the State Library and Supreme Court building, head back east and turn right at the intersection. In the triangle-shaped Columbus Green, between Lafayette and Washington Streets, is a statue of Columbus by Vincenzo Miserendino that was dedicated in 1926.

18. Second Church of Christ, Scientist
129 Lafayette Street

Facing the green is a Georgian Revival former church building. Constructed over several years in the 1920s, it was designed by Isaac A. Allen & Son.

Continue south on Washington Street.

19. Hartford County Building
95 Washington Street

First opened in 1929 as the Hartford County Courthouse (now the Hartford Judicial District Courthouse), this architectural mix of Classical and Art Deco was designed by Paul P. Cret of Philadelphia and Smith & Bassette of Hartford.

Continue south on Washington to the Italianate-style house on left.

20. Lucius Barbour House
130 Washington Street

This section of Washington Street was once a residential area nicknamed "Governors' Row" because among its many Victorian residences were the homes of governors William Ellsworth, Marshall Jewell, Richard Hubbard and Morgan G. Bulkeley. The only house to survive on this block today, the

Lucius Barbour House, displays signs of later alterations, most notably the enclosing of the front porch.

In the 1890s, this house was inherited by Lucius Barbour's son, Lucius A. Barbour, who was president of the Willimantic Linen Company. He updated the interior in the Colonial Revival style. His son, Lucius B. Barbour, as state examiner of public records, directed the compilation of the Barbour Collection of Connecticut Vital Records, an important source for the study of genealogy. The house is now used as offices.

Go back north on Washington Street to return to Bushnell Park.

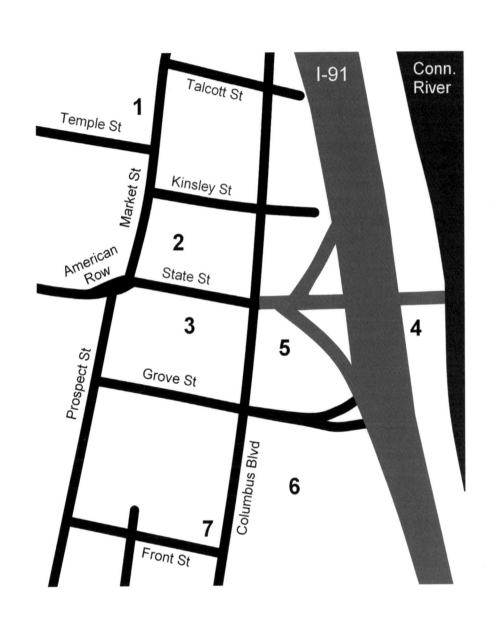

TOUR 4

Old and New East Side

B efore the coming of railroads, Hartford's commerce focused on the
Connecticut River. In colonial times, the riverfront was lined with
wharfs and warehouses used in the West Indies trade. Some of the town's
most prosperous residents were merchants, who lived in what would later be
called the East Side, between Main Street and the river. An intense period of
development began with the arrival of the railroad in 1839. With increasing
population and development, many wealthier residents began to move out
of downtown.

Successive waves of immigrant groups soon made Hartford's East Side
their home. In what was a training ground for economic mobility, newly
arrived families from Ireland, Germany, Italy and eastern Europe would
settle here and eventually move out to other neighborhoods when their funds
allowed it. Departing residents would quickly be replaced by newcomers,
who would then follow the same pattern. By the late nineteenth century,
streets like Front, Market, Charles and Talcott were home to densely
packed tenements, markets, saloons and warehouses. Residents lived in
overcrowded conditions on streets that were subject to frequent flooding, but
the neighborhood was also home to a lively ethnic culture.

The area of Front Street became an Italian American enclave,
nostalgically remembered today, that has been called Hartford's first "Little
Italy." By the 1950s, the neighborhood was considered to be in serious
need of redevelopment. In 1959, two hundred buildings, what remained of

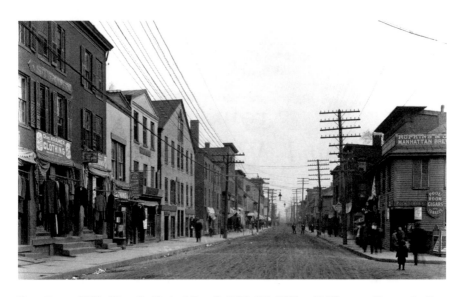

Front Street, 1906. *"Front St. North of Ferry St.," PG 430, William H. Thompson Photographs, State Archives, Connecticut State Library.*

the old East Side, were swept away for the massive urban renewal project called Constitution Plaza, constructed between 1962 and 1964. Costing $42 million, the result was a massive complex of eight major office buildings connected by elevated pedestrian plazas and bridges. Hailed upon its completion as a model undertaking of its kind, Constitution Plaza did not attract the hoped-for pedestrian activity. Its plazas were raised high above the surrounding streets, disconnected from the life of the city. Walkways that would have linked the plaza to Main Street were never built. The plaza's high-end retail shops did not prosper and eventually closed. Replacing a once vibrant neighborhood with twelve acres of empty concrete seemed to many a poor trade-off.

In recent years, new developments have helped to revive the area of downtown Hartford near the Connecticut River. The building of Interstate 91 had cut the city off from the river, but a new system of riverfront parks has been established to reconnect them. A new urban revitalization project is called Adriaen's Landing, named for Dutchman Adriaen Block, the first European to explore the Connecticut River Valley in 1614. The project led to the construction of a convention center, hotel and science center. Its latest component is sixty thousand square feet of retail and restaurant space, named Front Street after the long-vanished neighborhood.

This walking tour starts on the eastern side of the Old State House, at the intersection of Market Street, State Street and Central Row. With the statehouse on your left, head north on Market Street. Just after the intersection with Temple Street is a former church on the left.

1. St. Paul's Church
125 Market Street

Lined with modern buildings, Market Street looks completely different than it did when this church was constructed in 1855. Today, it is the only survivor of Hartford's old East Side. Built as a mission by the Episcopalians, it became the German Lutheran Church of the Reformation in 1880. In 1898, it began serving another immigrant group, Italian Americans, as St. Anthony's Roman Catholic Church. Later a Catholic information center, it is now the offices of Catholic Charities Migration and Refugee Services. At the northeast corner of the church, protected by a deed restriction, is the grave of Dr. Norman Morrison, who died in 1761 and was buried in what was then his garden.

Return toward the tour's starting point and cross to the east side of Market Street at the corner of State Street. Ascend the stairs and turn left toward the fountain.

2. Constitution Plaza

The streetscapes of Market Street and Front Street (now named Columbus Boulevard), with their many eighteenth- and nineteenth-century buildings, were replaced in the early 1960s by these modern structures. On your left, as you face the fountain, is 1 Constitution Plaza, by Kahn & Jacobs. Ahead and to the left is 100 Constitution Plaza, by Emery Roth & Sons. Broadcast House, which was home to WFSB-TV, once stood to your right. Broadcast House was demolished in 2009, and the CBS affiliate moved to Rocky Hill, Connecticut. This Plaza Level was landscaped by Sasaki, Walker & Associates. The fountain and free-standing clock tower, located farther ahead, were designed by Masao Kimoshita.

After exploring the Plaza Level, return past the fountain and cross the pedestrian bridge over State Street. Walk over to the unusually shaped modern office building.

3. Phoenix Building
One American Row

Popularly called the "Boat Building," the headquarters of the Phoenix Mutual Life Insurance Company was built in 1963 as part of Constitution Plaza. Designed in the International style by Max Abramovitz, it is a landmark of modernist architecture, being the world's first two-sided building. Phoenix was founded in 1851 as the American Temperance Life Insurance Company, which would only insure those who abstained from alcohol. A decade later, the name was changed to Phoenix, and nonteetotalers were thereafter welcomed.

Newer pedestrian walkways now connect the Phoenix Building to the nearby Travelers buildings and to Mortensen Riverfront Plaza and the new Science Center. Cross the walkway above Columbus Boulevard and head toward the Connecticut River on the plaza that spans Interstate 91.

4. Mortensen Riverfront Plaza
300 Columbus Boulevard

Completed in 1999, this plaza features a performance stage and connects to walkways and docks along the river. It is also the starting place for the Lincoln Financial Sculpture Walk, a collection that reflects the life and legacy of President Abraham Lincoln. The plaza was created by Riverfront Recapture, a private nonprofit organization created in 1981 to restore public access to the Connecticut River. The Founders Bridge Promenade leads pedestrians across the river to Great River Park in East Hartford. Originally part of Hartford, East Hartford became a separate town in 1783.

Head back across the plaza over I-91 and turn left toward the Science Center.

5. Connecticut Science Center
250 Columbus Boulevard

Designed by César Pelli & Associates, the Connecticut Science Center was opened on June 12, 2009. It features interactive exhibits, programs and live demonstrations.

Mortensen Riverfront Plaza. *Author photo.*

Either follow the elevated walkway or descend to Columbus Boulevard and proceed south to the convention center and Marriot Hotel.

6. Connecticut Convention Center
100 Columbus Boulevard

Designed by Thompson, Ventulett, Stainback & Associates and opened in 2005, the Connecticut Convention Center is the largest convention facility between New York and Boston.

Continue south on Columbus Boulevard. Across from the convention center's parking garage is the new Front Street.

7. Front Street District

As of this writing, leasing efforts for the new Front Street development are still underway. If you continue south and cross Arch Street, there is a plaque commemorating the old Front Street as you cross the bridge above the Whitehead Highway.

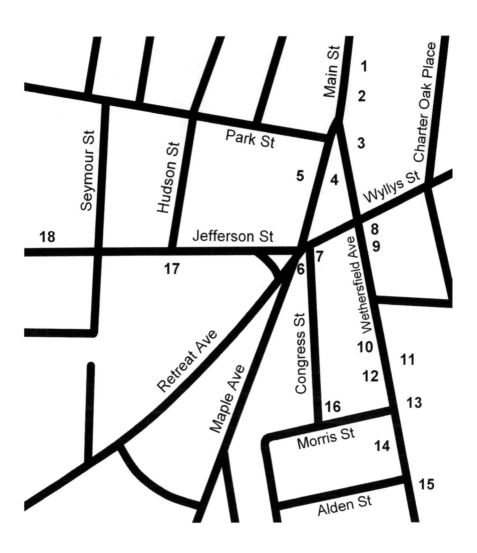

TOUR 5

South Green

This section is a walking tour of South Green, the neighborhood just south of downtown. Before it was placed underground, the Park River once formed a clear boundary between downtown Hartford and areas to the south. The neighborhood derives its name from the South Green, located at the south end of Main Street. Once a common pasture used by the early colonial community, it was fenced in to become a park in 1816. Several important roads split off from Main Street in the area of South Green, including Wethersfield Avenue, where many fine homes were built in the nineteenth century. The most notable was Armsmear, the extravagant mansion of firearms manufacturer Samuel Colt.

Begin this tour by heading south on Main Street from downtown, south of Charter Oak Avenue (south from stop no. 16 in Tour 1). As you head south, there are several notable buildings on the left (east) side of Main Street.

I. Ellery Hills House
214 Main Street

This impressive Greek Revival house is notable for its columned portico, which has an unusual elliptical curve. The house was built for Ellery Hills,

a shoe manufacturer. Builders of the time often made use of published architectural pattern books. This house has details derived from one such volume, *The Builder's Guide*, by Chester Hills, published in Hartford in 1834. A number of other Greek Revival houses once stood in this area, but only this house, now used as offices, survives today.

2. St. Peter's Church
160 Main Street

St. Peter's Catholic Parish was established in 1859 to serve Hartford's growing population of Irish immigrants. This brownstone church, designed by James Murphy, was built in 1868, and the tower was added in the 1920s.

3. Henry Barnard House
118 Main Street

Facing South Green is a house built in 1807. Henry Barnard (1811–1900) was born here and later lived in the house as an adult. Born into a wealthy family, Barnard graduated from Yale and practiced as a lawyer. Elected to the state's General Assembly in 1837, he became a reformer, devoted to improving Connecticut's system of common schools. He drafted a bill in 1838 that created a board of commissioners of the common schools and then served as its secretary. He produced many reports and articles that set forth his views that the state should ensure standards in the public schools. Barnard later became commissioner of public schools in Rhode Island, superintendent of common schools in Connecticut and principal of the Connecticut State Normal School in New Britain (now Central Connecticut State University). In 1867, he was appointed the first United States commissioner of education.

4. Barnard Park

In 1898, South Green was renamed Barnard Park, in honor of Henry Barnard. In the 1860s, Jacob Weidenmann, the landscape architect who designed Bushnell Park (see Tour 3), laid out the current arrangement of paths in the park. A fountain that was part of this design is now gone, but some of the ornamental cast-iron fence surrounding the park did survive.

5. South Park Methodist Church
75 Main Street

Facing Barnard Park on the west is a former Methodist church, built in 1875 and designed by James Jordan. In 1982, the church merged with the United Methodist Church on Farmington Avenue (see Tour 11). The building is now used as a homeless shelter.

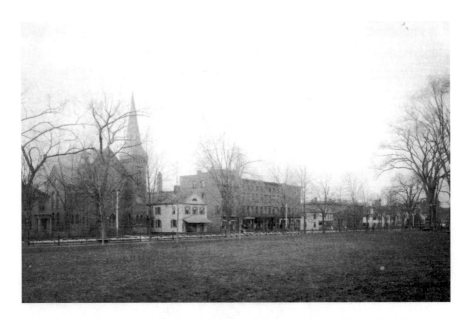

South Green and South Park Methodist Episcopal Church. *Hartford History Center, Hartford Public Library.*

6. Nicola Motto Building
1 Congress Street

This "flatiron" commercial building faces the southwestern tip of Barnard Park, where several streets intersect. Built in 1891 by Nicola Motto, a dealer in fruits and confectionery, the building has recently been restored.

7. Edmund Hurlburt House
2 Congress Street

Across Congress Street from the Motto Building is an Italianate-style house, built in about 1860. Edmund Hurlburt was a partner with James Ashmead in a goldbeating business.

Head east on Wyllys Street, across from the southern edge of Barnard Park, and turn right onto Wethersfield Avenue.

8. Mary Borden Munsill House
2 Wethersfield Avenue

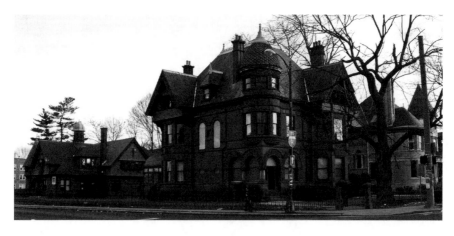

Mary Bodern Munsill House. The carriage house is on the left, and the Gail Borden Munsill House is on the right. *Author photo.*

One of Hartford's great Victorian residences, this elaborate house was built in 1893 for Mary Borden Munsill, the daughter of Gail Borden, who had invented condensed milk and founded Borden Milk Products. Behind the Munsill House is a substantial former carriage house that matches the main house's architectural features.

9. Gail Borden Munsill House
14 Wethersfield Avenue

After completing her own home on Wethersfield Avenue, Mary Borden Munsill had one built next door for her son in 1895. Designed by William H. Allen, Gail Borden Munsill's house contrasts with his mother's, being built of yellow brick and having features of the Colonial Revival style.

Continue south on Wethersfield Avenue. The next house is on the right.

10. Ashmead-Colt House
55 Wethersfield Avenue

This house was built in 1859 for James Ashmead (partner of Edmund Hurlburt, previously mentioned) and was later owned by Sam C. Colt, Colonel Samuel Colt's nephew. An Italianate-style house, it has a Second Empire tower and Colonial Revival front porch, both added later.

Across the street is the grand Italian villa that was the home of Samuel Colt.

11. Armsmear
80 Wethersfield Avenue

Samuel Colt (1814–1862) made his fortune in Hartford as a firearms manufacturer (for much more on Samuel Colt and his famous firearms

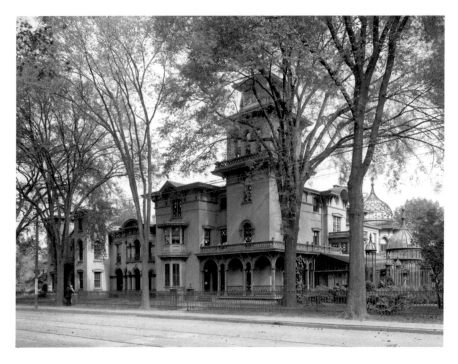

Armsmear, the home of Samuel and Elizabeth Colt, circa 1907. *Library of Congress, Prints and Photographs Division, Detroit Publishing Company Collection.*

factory, see Tour 6). In 1857, Colt built Armsmear, his appropriately named mansion, which was possibly designed by local architect Octavius Jordan. As it appears today, Armsmear has lost some of its most extravagant elements. Most notable is the absence of the glass-domed conservatories, which were added in 1861–62. The interior once contained the fine furniture, Hudson River School paintings and numerous awards collected by Samuel Colt and his wife, Elizabeth Jarvis Colt. Armsmear represented the height of Victorian Hartford society. When Elizabeth Colt died in 1905, she deeded the house as a residence for the widows of Episcopalian ministers.

12. Day-Taylor House
81 Wethersfield Avenue

Across from Armsmear is one of Hartford's most charming Victorian houses. It is an Italianate villa, constructed in 1858 and first owned by Albert Day, a merchant. It was the residence of Mary Borden Munsill from 1879 until her own house was built nearby. Edwin Taylor, president of the Taylor Lumber Company, next bought the house, and his family lived here until 1928.

13. Colt Park

Adjacent to Armsmear on the south is the entrance to Colt Park. These were once the extensive grounds of the Colt property and included picturesque ponds, fountains, sculptures, greenhouses and a deer park. They were left to Hartford as a park by Elizabeth Colt in 1905. Near the park entrance is a granite and bronze memorial to Samuel Colt commissioned by Elizabeth Colt and dedicated in 1906. Sculpted by John Massey Rhind, it features figures of the young Colt as a boy and the mature Colt as a successful manufacturer. Two bronze panels depict Colt meeting with the Russian tsar and Colt demonstrating his revolver to the British House of Commons.
Continue south on Wethersfield Avenue to the church on the right.

14. St. Michael's Ukrainian Catholic Church
135 Wethersfield Avenue

Designed by John J. McMahon, this church was built in 1952.
Just south of Colt Park is another Colt family residence.

15. James Colt House
154 Wethersfield Avenue

This house was built in 1856 for Samuel Colt's brother, James Colt. It shares many architectural features with Armsmear. The next two houses to the south were built in the 1880s by Elizabeth Colt, who ran Colt's Manufacturing Company after the death of her husband in 1862. The house on the north (176 Wethersfield Avenue) was the residence of the superintendent of the Colt Armory, and the house on the south (180 Wethersfield Avenue) was, for a time, the rectory of the Church of the Good Shepherd (see Tour 6).

If you are walking, turn around and head back north on Wethersfield Avenue and turn left on Morris Street. On the right is Congress Street. If you are driving, you can head south on Wethersfield Avenue, turn right on Annawan Street and then right on Dean Street. Follow Dean Street as it curves to the right and becomes Morris Street. Congress Street will be on the left. If you are walking, you can proceed down the street. If you are driving, you will have to park first, or drive down Congress Street from Wyllys Street, because it is a one-way street.

16. Congress Street

From here, Congress Street runs one block north to Barnard Park/South Green. The street was laid out in 1855, and the Italianate houses on the west side were constructed soon thereafter. In contrast to the mansions on Wethersfield Avenue, Congress Street represents a surviving row of more modest homes that maintains the appearance of a nineteenth-century streetscape. In the 1860s, Francis Pratt lived at no. 39 and Amos Whitney at no. 33. In 1860, they founded a company that manufactured machine tools.

Return to the intersection of Congress Street and Wyllys Street by either walking north on Congress Street or driving east on Morris Street, turning left on Wethersfield Avenue and then left on Wyllys Street.

17. Hartford Hospital

To the west are the buildings of Hartford Hospital. On March 2, 1854, a steam boiler explosion at the Fales and Gray railroad car factory led to nine deaths at the scene of the accident. Ten more men would later die from their injuries. Hartford had no general hospital at the time, and the disaster led to the founding that year of Hartford Hospital.

Today, Hartford Hospital has a large campus of buildings covering sixty-five acres, the bulk of which are located in the triangle formed by Jefferson Street and Retreat Avenue. Older surviving buildings along the north side of Retreat Avenue are the Hall-Wilson Building (Carl J. Malmfeldt), built as a laboratory in 1921, and the Brownstone Building, built in 1923 as the Women's Building and now home to the Outpatient Department. On the south side of Jefferson Street are the Florence Crane Building (Kendall, Taylor & Company), built in 1930, and the Cheney Building (Carl J. Malmfeldt), built as a library in 1928. On the north side of Jefferson Street is Allen House (Carl J. Malmfeldt), built in 1924 as the hospital superintendent's residence. In contrast to the hospital's many later buildings, these early twentieth-century structures were all designed in the Georgian Revival style.

Head west on Jefferson Street to the Victorian house on the north side of the block between Seymour Street and Washington Street.

18. Levi Lincoln Felt House
142 Jefferson Street

Felt was born in New York City in 1849 and later settled in Hartford, working after 1864 for the Travelers Insurance Company, where he became controller. Felt was also interested in his family's genealogy, conceiving and doing preliminary work for *The Felt Genealogy*, published in 1893.

Retrace your route east on Jefferson Street to return to South Green/Barnard Park.

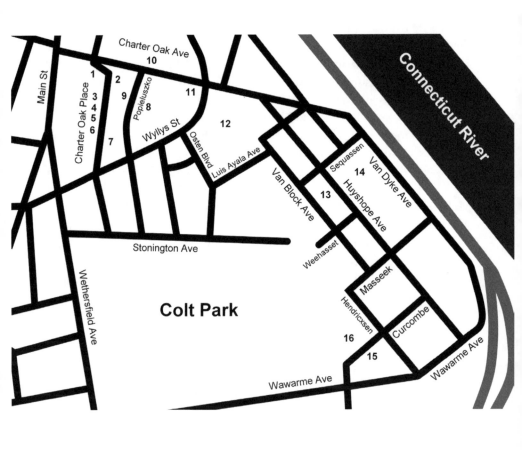

TOUR 6

Sheldon—Charter Oak

S heldon–Charter Oak is a neighborhood south of Sheldon Street and
Charter Oak Avenue, between Wethersfield Avenue and the Connecticut
River. Some landmarks on the edges of this area have been covered in Tours
1 and 5. This tour visits the Victorian houses of Charter Oak Place and
proceeds to the sites of "Coltsville," which encompasses the landmarks of
Colonel Sam Colt's revolutionary manufacturing enterprise.

In this neighborhood, the Park River connects to the Connecticut River
through an underground conduit. In 1633, the Dutch established a trading
post on the south bank of the river, then known as the Little River to contrast
it with the Connecticut, the Great River. The area became known as Dutch
Point, and the name of the Dutch fort, the "House of Hope," is reflected in
the name of Huyshope Avenue. It was near here that Colt would build the
complex of Colt's Patent Fire Arms Manufacturing Company. Colt named
many of the streets in this area after the early Dutch explorers and the Native
Americans who signed deeds conveying the land to them.

Samuel Colt was born in Hartford in 1814 and as a young man went to
sea. On a voyage to India, he carved a wooden model for his new invention,
a pistol with an automatic revolving chamber that could fire several times
before needing to be reloaded. Colt took out his first patent in 1835, but
his new firearm did not gain immediate acceptance and suffered from
production defects. His first company, based in Paterson, New Jersey, shut
down in 1842, but the irrepressible Colt moved on to other manufacturing

ventures. Government orders during the Mexican-American War soon gave new life to Colt's revolver business.

In 1855, he completed his armory building in Hartford, at the time one of the largest manufacturing complexes in the world. It was also a planned community, with workers' housing and Colt's own mansion, Armsmear, on Wethersfield Avenue (see Tour 5). At this facility, Colt pioneered new techniques of mechanization and precision manufacturing. He was also a genius at marketing and public relations, promoting his brand around the world. When he died at age forty-seven in 1862, his widow, Elizabeth Jarvis Colt, took over the company, which continued its success during the Civil War and provided the revolvers used in the American West. Elizabeth Colt was also a patron of the arts and a philanthropist who left her estate to the city to become Colt Park (see Tour 5).

Begin the tour by heading east from Main Street on Charter Oak Avenue. Turn right onto Charter Oak Place, near the Charter Oak Monument (stop no. 18 in Tour 1).

1. Site of the Wyllys Estate

The ground, which rises here, was once part of the Wyllys estate, site of the Charter Oak (see Tour 1). George Wyllys (1590–1645) was one of the wealthiest men in New England when he settled in Hartford in 1638. Two years earlier, his steward, William Gibbons, had arrived in Hartford with twenty indentured servants and built Wyllys a nine-room "mansion" that was more substantial than any other in the newly settled town. Wyllys served as governor of Connecticut in 1642 and commissioner from Connecticut to the United Colonies of New England in 1643. He is buried at the Ancient Burying Ground.

His house was torn down in 1827. It was located near Governor Street, so named because three other colonial governors—John Webster, Thomas Welles and Edward Hopkins—also had homes here. Governor Street is now named Popieluszko Court.

Continue up the hill on Charter Oak Place, which has a number of nineteenth-century houses.

2. Pease and Fenn/Eaton Double Houses
40–38 and 36–34 Charter Oak Place

These are two Italianate duplex houses, built in 1862 and 1863, respectively. Because of the hill sloping down behind these houses, they actually have five stories, not just the two visible from Charter Oak Place.

3. Nathaniel Shipman House
33 Charter Oak Place

This Italianate house was built in 1860 for Nathaniel Shipman, a lawyer and federal judge. His family lived here until 1912.

4. Kingsbury-Gatling House
27 Charter Oak Place

Also built in 1860, this house was constructed for the Kingsbury family. It was later the residence of Dr. Richard J. Gatling, inventor of the Gatling gun, the first successful rapid-fire weapon and the forerunner of the modern machine gun. Later still, the house was the residence of A.C. Williams, president of Capewell Manufacturing.

5. James Niles House
19 Charter Oak Place

This house was built in about 1869 for manufacturer James Niles.

6. Robinson-Smith House
15 Charter Oak Place

Built in 1864, this was a two-family house that was originally the home of two flour merchants, Charles Robinson and James Smith. This large house combines elements of various architectural styles. Its originally symmetrical front was altered by the additions on the south side.

7. Colonel Charles H. Northam House
12 Charter Oak Place

This Victorian house is commonly called the "Painted Lady." It was built in 1875 for Charles H. Northam, a wealthy merchant and philanthropist, who donated the Northam Memorial Chapel at Cedar Hill Cemetery and Northam Towers at Trinity College (see Tour 7).

At the south end of Charter Oak Place, turn left on Wyllys Street. Take the next left onto Popieluszko Court, the former Governor Street. Continue to the building on the right, just past the parking lot.

8. Capewell Horse Nail Factory
60 Popieluszko Court

This building, with its elaborate brick, brownstone and terra-cotta façade, was built in about 1900 as the offices of the Capewell Horse Nail Factory. Next door, at the end of Popieluszko Court, is the factory building, which has a Romanesque Revival tower with a pyramidal roof. The factory was built of fireproof material in 1903, replacing an earlier factory that had burned down in 1901. The company, which is still in existence, was founded in 1881 after George Capewell invented an improved machine for making horseshoe nails.

This neighborhood was once the center of a vibrant Polish immigrant community, and the next two landmarks still serve Polish Americans in the region. Popieluszko Court was named for Father Jerzy Popieluszko, a Polish

priest who was murdered in Poland in 1984 by three agents of the then communist government's internal intelligence agency.

9. SS. Cyril and Methodius Church
63 Popieluszko Court

SS. Cyril & Methodius Parish was founded in 1902 to serve Polish Catholics. This church, designed by T.G. O'Connel, was completed in 1917.

10. Polish National Home
60 Charter Oak Avenue

At the end of Popieluszko Court, across Charter Oak Avenue, is the entrance to the parking lot of the Polish National Home. It was built in 1930 and was designed by Henry F. Ludorf in the Art Deco style.

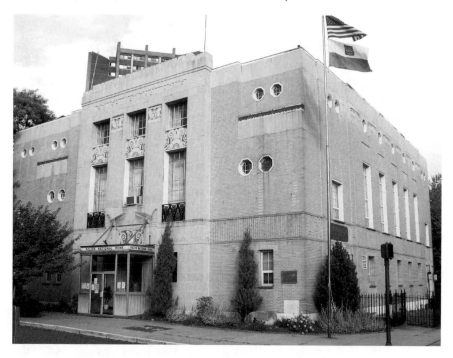

Polish National Home. *Author photo.*

Turn right on Charter Oak Avenue and continue past the Capewell factory. There is another factory on the right.

11. Atlantic Screw Works
75–85 Charter Oak Avenue

Atlantic Screw Works came to Hartford in 1879 and rented space in the Colt Armory. The two-story factory was built here in 1902, and the connected three-story building, designed by Davis & Brooks, was added in 1910.

Turn right on Wyllys Street. Head to the church on the left.

12. Church of the Good Shepherd
155 Wyllys Street

After the death of her husband in 1862, Elizabeth Colt planned to erect an Episcopal church as a memorial to Sam Colt and three of their four children, all of whom had died within a five-year period. In 1866, she commissioned Edward Tuckerman Potter, the architect who would later design the Mark Twain House (see Tour 10). Completed in 1869, Potter's High Victorian Gothic church is an architectural landmark with some unique features, such as the crossed Colt pistols and revolver parts carved in sandstone around the south "Armorer's Door."

Next door is the church's ornate parish house. It was also designed by Potter, who was persuaded by Elizabeth Colt to come out of retirement for the project. The new structure was built as a memorial to her son, Caldwell Hart Colt, an ardent yachtsman, who had died at sea under mysterious circumstances. Many of the decorative features on the building have a nautical inspiration. Completed in 1896, its High Victorian Gothic style was out of fashion when it was built but matched well the style of the original church.

Continue west on Wyllys Street, turn left onto Osten Boulevard and then turn left onto Luis Ayala Avenue, which passes to the rear of the Church of the Good Shepherd property. Turn right on Van Block Avenue. After the intersection with Sequassen Street, note the houses on the east side of Van

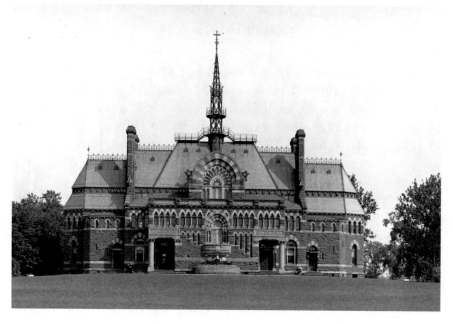

Church of the Good Shepherd Parish House, circa 1905. *Library of Congress, Prints and Photographs Division, Detroit Publishing Company Collection.*

Block Avenue. Turn left on Weehasset Street and left on Huyshope Avenue. Note the five houses on the left side of the avenue.

13. Colt Worker Houses
60, 64, 68, 72, 76 Van Block Avenue
101, 111, 121, 133, 141 Huyshope Avenue

The section of Van Block between Sequassen Street and Weehasset Street is lined with five houses. Parallel to Van Block Avenue to the east is Huyshope Avenue, whose corresponding block also has five houses. All ten buildings were built in 1856 to house Colt's factory workers. There were once about fifty such houses, but only these ten survive.

14. Colt Armory
55 Van Dyke Avenue

Visible to the east are the Colt factory buildings. The most notable is the East Armory, with its distinctive dome, which is a familiar landmark to travelers on nearby Interstate 91. In 1864, three years after Samuel Colt's death, his original armory of 1855 was destroyed by fire. It was rebuilt in 1867 by Colt's widow, Elizabeth Colt, using designs by the company's general manager, General William B. Franklin. The new building was designed to be fireproof and is one story taller than its predecessor.

The new armory reproduced the most recognizable feature of the original structure: the blue onion dome with gold stars, topped by a golden orb and a sculpture of a *Rampant Colt*, a symbol of the company. The colt is a fiberglass replica of the gilded wooden original that is now displayed at the Museum of Connecticut History (see Tour 3). There are different theories as to why Colt used this distinctive dome. It was possibly a tribute to his early Russian business contacts. It may also have been intended as a dramatically memorable marketing statement.

Colt Armory, circa 1900–1906. *Library of Congress, Prints and Photographs Division, Detroit Publishing Company Collection.*

Continue on Huyshope Avenue and turn left on Sequassen Street and then left on Van Block Avenue. Continue on Van Block, turn right on Maseek Street, left on Hendricxsen Avenue and then right onto Curcombe Street. There is a row of houses on the left.

15. Potsdam Village
13, 17, 21, 23, 29, 33, 37, 41, 45 Curcombe Street

To protect his armory from flooding, Samuel Colt constructed a dike along the Connecticut River. Willow trees flourished there, inspiring Colt to import workers from Potsdam, Germany, to produce furniture from the willows' wood. Colt constructed these nine "Swiss Cottages" to house his imported workers. Most have been greatly altered, but several still display original architectural features, including brick first floors with decorative half-timbering, board-and-batten siding on the second floor and prominent overhanging eaves.

16. Hartford Base Ball Grounds at Colt Meadows

Since 2009, vintage baseball teams have met to play 1860s- and 1880s-style games in a section of Colt Park across from the Potsdam houses. The Colt Armory had a factory team that played from 1866 to 1918, often in "the south meadows," an area of what is now Colt Park. In 1874, Morgan G. Bulkeley, later a governor of Connecticut and first president of the National League, formed the Hartford Base Ball Club. He constructed the Hartford Base Ball Grounds, which could seat two thousand, on land he leased adjacent to the Church of the Good Shepherd. The Hartford Dark Blues played there from 1874 to 1876. The team moved to Brooklyn, New York, for the 1877 season and then disbanded.

Follow Curcombe Street southwest to Wawarme Avenue and turn right. Take the next right onto Wethersfield Avenue and head north to return to Main Street.

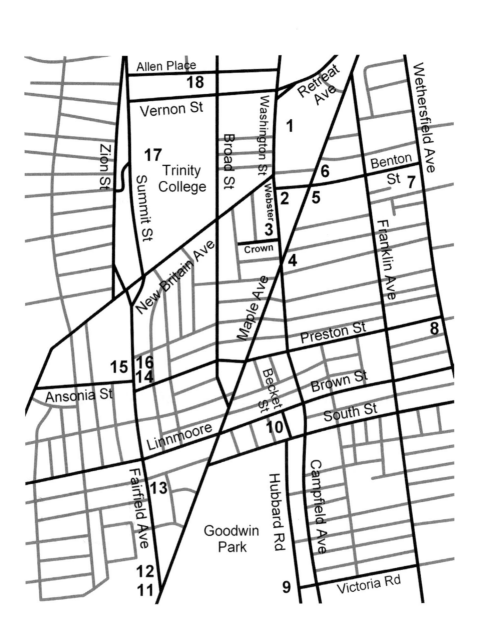

TOUR 7
South End

This tour presents a driving route of Hartford's South End. The South End was predominantly farmland until after the Civil War. Development here accelerated with the introduction of the horse railroad, followed later by trolley lines. Several major commercial avenues (Wethersfield, Franklin, Maple and New Britain) head south and southwest through the area, intersected by numerous residential streets. The tour begins along Washington Street, south of Retreat Avenue, where the buildings of the Institute of Living are located. The main entrance to the Institute is on Retreat Avenue.

1. Institute of Living
200 Retreat Avenue

Retreat Avenue gets its name from the Connecticut Retreat for the Insane, now called the Institute of Living. Founded in 1822, it was one of the first mental health centers in the United States. In 1823, work began on the Center Building, which was enlarged in 1868 by Vaux & Withers. A number of other buildings have been added over the years, including Elizabeth Chapel in 1875 and White Hall in 1877, both designed by Hartford

architect George Keller. The institute's parklike grounds were laid out in the 1860s by Frederick Law Olmsted, working with Calvert Vaux and Jacob Weidenmann. The Institute of Living merged with Hartford Hospital (see Tour 5) in 1994.

As you follow Washington Street south, the former Washington Street School is on the right, at the intersection with New Britain Avenue. It was later named the Michael D. Fox School and moved to a new building. Washington now becomes Webster Street. There is a Victorian house on the southeast corner of Webster Street and Benton Street.

2. George W. Fuller House
96 Webster Street

This Italianate villa with a Second Empire mansard-roofed tower was built in about 1875 for George W. Fuller, who owned a store that sold trunks and luggage.

Continue south on Webster Street to the theater on the corner of Crown Street.

3. Webster Theatre
31 Webster Street

Opened in 1937 as a movie theater, in more recent years the Webster has thrived again as a music venue. The Art Deco building was designed by George A. Zunner Jr.

Continue south to where Webster Street intersects with Maple Avenue. Ahead is a triangle, where Maple Avenue forks to the right and Campfield Avenue is on the left. Follow the right fork (Maple) and turn left on Baker Street (it looks like the entrance to a parking lot) just after the triangular green. Turn left on Campfield Street, and on your right is a church.

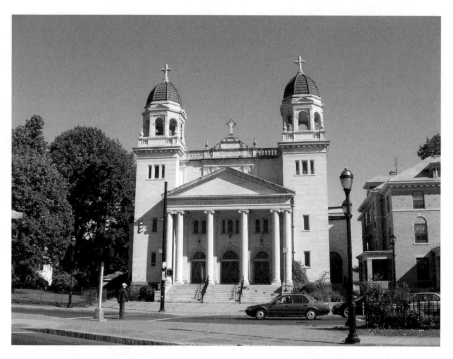

St. Augustine Church, Barry Square. *Author photo.*

4. St. Augustine Church
10 Campfield Avenue

This area is the heart of the neighborhood called Barry Square. It is named for Father Michael Barry, who in 1902 became the founding pastor of the newly established St. Augustine Parish. A basement chapel was completed in 1903, and the completed church was dedicated in 1912.

Ahead, follow the right fork (Maple Avenue).

5. Michael D. Fox Elementary School
470 Maple Avenue

At the southeast corner of Maple Avenue and Benton Street is a Gothic-style school building designed by Frank Irving Cooper with Edward

T. Wiley. It was completed in 1924 as Bulkeley High School. The same architects had completed Weaver High School, at 25 Ridgefield Street in the Upper Albany neighborhood, in 1922. Both high schools were later moved to newer buildings. The old Weaver building became Martin Luther King Jr. Elementary School, and Bulkeley became Michael D. Fox Elementary School, which had earlier been located in the building at 461 Washington Street.

Continue north on Maple Avenue. There is a cemetery on the right.

6. Old South Burying Ground
400 Maple Avenue

The Old South Burying Ground was established in 1801 as Hartford's second burying ground. In the eighteenth century, this land had been part of the Benton farm and contained an apple orchard and the Benton family's burial yard. It was later purchased by Thomas Y. Seymour, who sold it to the city. Seymour had served as an officer in the Revolutionary War and was selected to escort the captive British general John Burgoyne to Boston after his surrender at the Battle of Saratoga in 1777. Seymour was buried at Old South in 1811. Another notable person buried here is Hannah Bunce Watson Hudson, who became the first female publisher of the *Hartford Courant* in 1777 after the death of her first husband, Ebenezer Watson, the newspaper's second publisher. There have recently been efforts to make repairs to this long-neglected burying ground.

Just after the Old South Burying Ground, turn right onto Shultas Place. Cross Franklin Street and continue to Wethersfield Avenue. Turn right on Wethersfield Avenue.

7. Trolley Barn
331 Wethersfield Avenue

The large building on the right side of Wethersfield Avenue, south of Benton Street, was built in 1903 by the Hartford Street Railway Company.

It replaced earlier stables on the site, constructed in 1862 by the Hartford & Wethersfield Horse Railroad Company. Later used as an area for boxing and other events, the building was rehabilitated in 2004 as a facility of the Village for Families and Children (see Tour 12).

Continue south on Wethersfield Avenue to the school on the right, just below Preston Street.

8. Henry C. Dwight Elementary School
585 Wethersfield Avenue

The two sections of this school illustrate the population growth in the South End in the late nineteenth century. The older Victorian section, built in about 1885, is on the right. It was followed by an even larger addition, on the left, in 1901. The school is named for Henry C. Dwight, who was mayor of Hartford in 1890–92 and chairman of Hartford's South School District.

Continue on Wethersfield Avenue and turn right on Brown Street. At the next intersection, turn left onto Franklin Avenue. With the destruction of the Front Street neighborhood in the late 1950s (see Tour 4), many Italian American businesses moved here to Franklin Avenue. While other ethnic groups have also established themselves in the area in recent years, Franklin Avenue is still home to a large number of Italian restaurants, markets, bakeries and other businesses.

Head south on Franklin and turn right on Victoria Road, which ends at a park entrance.

9. Goodwin Park

Goodwin Park was constructed in 1901 to the plans of the Olmsted Brothers firm. At first, it was called South Park, but it was soon renamed for Reverend Francis Goodwin, who was the first president of the park board under a newly adopted city charter. Goodwin Park's main feature was a large meadow, later replaced with a golf course. Starting in 1918, Hartford's first airmail planes landed in Goodwin Park. In 1921, two young airmen were

killed while trying to land in the park. This event prompted Mayor Newton C. Brainard to construct a proper landing field in Hartford. Dedicated on June 11, 1921, Brainard Field, in Hartford's South Meadows, was then the only municipal airport located between New York and Boston. It is now Hartford-Brainard Airport.

Turn right and head north on Hubbard Road. Turn right on South Street and then make an immediate left onto Becket Street. Drive to the church on the left side of the street.

10. St. Panteleimon Russian Orthodox Church
19 Becket Street

St. Panteleimon Russian Orthodox Church was built by a parish of the Russian Orthodox Church Outside Russia. The Russian Orthodox Church Outside Russia (ROCOR) was formed by Russian émigrés after the Russian Revolution. It is a semiautonomous part of the Russian Orthodox Church with more than four hundred parishes around the world. The Hartford parish was organized in 1958, and the church was built in 1972. It was designed by Father Dimitri Alexandrow, working with the architectural firm of Austin & Mead. Father Dimitri (1930–2010), who was the congregation's priest and a master icon painter, taught himself architecture in order to design the church. He was later consecrated a monk, taking the monastic name of Daniel, and in 1988 he was consecrated as bishop at the Russian Orthodox Old Rite Church of the Nativity in Erie, Pennsylvania.

Continue on Becket Street and turn right on Brown Street. Turn right on Campfield Avenue and take the next right onto South Street. Continue on South Street and then turn left onto Maple Avenue. Head south on Maple Avenue. Just after the intersection with Fairfield Avenue, the entrance to Cedar Hill Cemetery is on the right.

11. Cedar Hill Cemetery
453 Fairfield Avenue

Cedar Hill Cemetery, established in 1864, represents the culmination of the nineteenth-century rural cemetery movement. Beautifully landscaped by Jacob Weidenmann, architect of Bushnell Park (see Tour 3), this privately managed cemetery resembles a park, with woodlands, meadows and ponds. Many of the striking monuments here were designed by well-known architects. The monument for businessman George Beach resembles the cupola of the state capitol—both the monument and the capitol were designed by Richard M. Upjohn. At the entrance to Cedar Hill are several Gothic structures designed by Hartford architect George Keller. Northam Chapel, a gift of Colonel Charles H. Northam (see Tour 6) and his wife, Susan, was built in 1882. The Gallup Memorial Gateway, a gift of Mrs. Julia Gallup, was built in 1888. There is also a superintendent's cottage, constructed in 1875.

Many of the prominent Hartford citizens buried here are of national and international importance. Among these are Gideon Welles, Lincoln's secretary of the navy, and Horace Wells, discoverer of anesthesia (see Tour 1); businessmen James G. Batterson and Gilbert F. Heublein (see Tour 2); Samuel

Northam Memorial Chapel and Gallup Memorial Gateway, Cedar Hill Cemetery. *Author photo.*

and Elizabeth Colt (see Tours 5 and 6); George Capewell and Governor Morgan G. Bulkeley (see Tour 6); and brothers Henry and Walter Keney (see Tour 8). Also buried here are Thomas Hopkins Gallaudet, founder of the American School for the Deaf; Reverend Joseph Hopkins Twichell; author Charles Dudley Warner; Senator Joseph Hawley; and activists John and Isabella Beecher Hooker (all mentioned in Tour 10). Famed actress Katharine Hepburn, the influential brothers James and Francis Goodwin and the park's designer, Jacob Weidenmann, are also buried here.

Born in Hartford, John Pierpont Morgan (1837–1913), the wealthy and influential financier, banker, art collector and philanthropist, is also interred at Cedar Hill Cemetery. Morgan's granite monument, said to represent his vision of the Ark of the Covenant, was designed by George Keller.

Exiting Cedar Hill Cemetery, turn left onto Fairfield Avenue. There is a church on the left.

12. St. George Greek Orthodox Cathedral
433 Fairfield Avenue

St. George Parish was organized in 1931. The parish rented and later purchased a former Baptist church on Jefferson Street in Frog Hollow. In 1966, the parish moved to its new church on Fairfield Avenue.

Continue on Fairfield Avenue, where the next four buildings are located.

13. Robert T. Smith House
316 Fairfield Avenue

Fairfield Avenue, located along heights overlooking the city to the east, became one of Hartford's prime residential streets after the Civil War. Numerous homes in a variety of architectural styles were built here between the 1850s and 1930s. This Colonial Revival–style house was built in 1909 for Robert T. Smith. He was a partner with Robert N. Seyms in Seyms & Company, 72–74 Front Street, a firm that was advertised as importers of "Teas, Coffees, Spices, Cigars, Tobaccos and Grocers' Specialties."

14. George A. Fairfield House
160 Fairfield Avenue

Fairfield Avenue took its name from George A. Fairfield (1834–1908), who built this extravagant Second Empire–style house in 1866, when this area was still predominantly rural.

15. Oliver H. Easton House
147 Fairfield Avenue

In 1869, Oliver H. Easton followed George A. Fairfield in building another impressive Second Empire–style house. Easton (1812–1894) was a builder and architect who constructed his own home on Fairfield Avenue when he retired after a forty-year career.

16. Memorial Baptist Church
142 Fairfield Avenue

Memorial Baptist Church was organized in 1884. Its original building was on the corner of Washington and Jefferson Streets. This church, designed by Isaac A. Allen & Son in the Colonial Revival style, was begun in 1931 but, due to the Great Depression, was not completed until 1949.

Continue on Fairfield until it forks on either side of a green. Follow the fork to the left, crossing New Britain Avenue. Fairfield Avenue becomes Zion Street. Continue north on Zion and take the road on the right, College Terrace, which leads up the hill to Summit Street and the campus of Trinity College.

17. Trinity College
300 Summit Street

Originally called Washington College, Trinity College was founded in 1823 by Thomas Brownell, an Episcopal bishop. The state was then still dominated by Congregationalists, who granted the college a charter that prohibits the imposition of religious standards on students, faculty or staff. When the state capitol was built on the site of the college's first campus in the 1870s (see Tour 3), Trinity moved to a new home on this ridge, which was known as Gallows Hill because of the public executions that once took place here.

A large and impressive quadrangle was planned for the college by English architect William Burgess, but only one section of the ambitious and expensive plan, supervised by architect Francis Kimball, was ever completed. Called the Long Walk, it is the architectural centerpiece of the Trinity campus and is recognized as one of the best examples of the Victorian collegiate Gothic style in the world. The central Northam Towers are flanked by Jarvis and Seabury Halls. The Long Walk recently underwent an extensive restoration.

Many other buildings have been constructed in various architectural styles by Trinity College over the years, including the Austin Arts Center in 1965 and the Brutalist-style Albert C. Jacobs Life Sciences Center in 1969. The Trinity College Chapel, a Gothic structure completed in 1932, was designed by Philip H. Frohman, architect of the Washington National Cathedral. Sixty-six of the chapel's seventy-eight pew ends and kneeler ends were carved by J. Gregory Wiggins between 1932 and his death in 1956.

Long Walk, Trinity College, circa 1905. *Library of Congress, Prints and Photographs Division, Detroit Publishing Company Collection.*

Trinity College Chapel. *Author photo*.

On Vernon Street are several former houses that are now used by the college. The notable Georgian Revival–style house at 81 Vernon Street was built for Francis H. Adriance in 1896 to the designs of Hapgood & Hapgood. It is now the Psi Upsilon fraternity house. St. Anthony Hall, at 98 Summit Street, is a Gothic building designed by J. Cleveland Cady. It was built in 1878 for the Epsilon Chapter of Delta Psi.

Head north on Summit Street and turn right onto Allen Place.

18. 125 Allen Place

Allen Place was laid out in 1869 and has houses of various architectural styles popular in the nineteenth century. This house, built in about 1875, is an excellent example of a Gothic Revival cottage, sometimes referred to as the "Carpenter Gothic" style.

Continue on Allen Place to the intersection with Washington Street, which is just north of where this tour began.

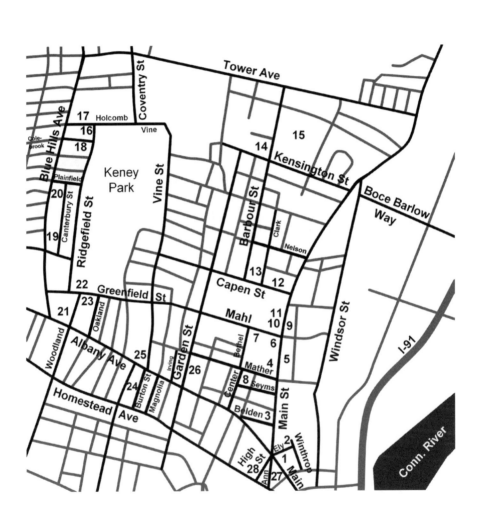

TOUR 8
North End

This section presents a driving tour of Hartford's northern neighborhoods: Clay-Arsenal, Northeast, Upper Albany and Blue Hills. Just north of downtown, Main Street makes a sharp turn to the northwest. At Tunnel Park (named for the railway tunnel running underneath it), Main Street turns again to the north, while the route continuing northwest becomes Albany Avenue. Main Street passes through the Clay-Arsenal and Northeast neighborhoods to Hartford's border with the town of Windsor. Albany Avenue, which continues into West Hartford, is the main route through the Upper Albany Neighborhood. Blue Hills Avenue heads north from Albany Avenue through the Blue Hills neighborhood and into the town of Bloomfield. This driving tour makes a large loop, heading north on Main Street, next making its way to Blue Hills Avenue and then returning on Albany Avenue.

The North End of Hartford was largely farmland and open areas until after the Civil War. Postwar prosperity and development downtown led to the subdivision of farmland in northeast Hartford, a process spurred on by the extension of the horse railway up Main Street to Capen Street in 1869. Development to the northwest came later. Construction of a trolley line up Albany Avenue in 1896 led to a construction boom, and many new streets were opened. The Blue Hills area was built up more gradually during the first half of the twentieth century.

Waves of various ethnic groups have made Hartford's north neighborhoods their home. Original Yankee farmers were followed by

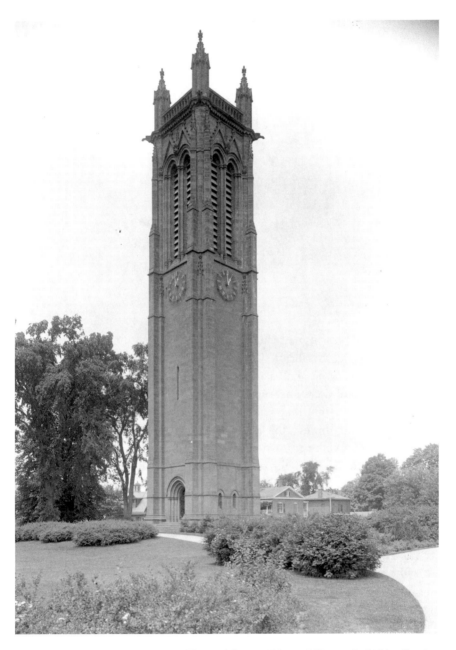

Keney Memorial Tower, circa 1905. *Library of Congress, Prints and Photographs Division, Detroit Publishing Company Collection.*

waves of Irish, German and Jewish immigrants. After World War II, Hartford's north neighborhoods became home to a predominantly African American and Latino population. Postwar economic decline led to urban decay, and many parcels of land became empty after now vacant buildings were demolished. Damage was caused by riots on April 4, 1968, following the assassination of Dr. Martin Luther King Jr. The North End was also physically separated from the rest of Hartford by the construction of Constitution Plaza and Interstate 84. In recent years, revitalization efforts have led to the rehabilitation of numerous historic structures. The Hartford Housing Authority has replaced old and sprawling housing projects with attractive single-family townhouses.

Heading northwest from downtown on Main Street, turn right onto Ely Street, just before the large intersection where Main turns north and Albany Avenue begins. The first stop is the large Gothic tower on the corner.

1. Keney Memorial Tower

The Keney Memorial, designed by Charles C. Haight, is a freestanding clock tower that rises to 130 feet. Dedicated in 1898, it was built where the old homestead and wholesale grocery business of Henry and Walter Keney once stood. Raised by their widowed mother, Rebecca Turner Keney, the two brothers became very successful, and as neither of them had children, they were very generous in their bequests to the city. In his will, Henry Keney (1806–1894) set aside funds for the creation of Keney Park and also for the construction of a memorial to the memory of the firm of H. & W. Keney. The trustees of the Keney estate decided not to dedicate the memorial to the Keney business, as Henry Keney had intended. As the bronze plaque inside notes:

> *This tower, erected to the memory of my mother, is designed to preserve from other occupancy the ground sacred to me as her home and to stand in perpetual honor to the wisdom, goodness and womanly nobility of her to whose guidance I owe my success in life and its chief joy.—Henry Keney*

2. Sacred Heart Church
49 Winthrop Street

Facing Ely Street is a Catholic church with a yellow-brick façade. A basement chapel, designed by Michael O'Donahue, was completed first, in 1893. The rest of the Gothic structure, finished by architect George A. Zunner Sr., was dedicated in 1917. Originally built by a group of German Catholic immigrants, masses are now held in Spanish for the predominantly Puerto Rican congregation.

Because Ely Street is one-way, return to Main Street by turning right onto Winthrop Street, then right onto Pleasant Street and finally right onto Main Street. Continue on Main Street as it turns to the right.

3. The Belden
1545–1555 Main Street

At the corner of Main Street and Belden Street is a large apartment building, one of the first of its size to be constructed in Hartford. It was larger when it was built in 1898, but a section of the building along Main Street was destroyed in a fire in 1980. The building, called the Belden, has since been restored and partially rebuilt. Both the building and the street derive their names from Thomas Belden, who had once been a major owner of land north of Albany Avenue.

Belden Street has a number of surviving late nineteenth-century houses, the most striking of which is the Samuel F. Cadwell House at 20 Belden Street. This recently rehabilitated red brick Victorian Gothic cottage is located next to the Belden. Sometimes referred to as the "Mark Twain House of the North End," it was built in 1879 for Samuel Foote Cadwell, a dealer in seeds and agricultural supplies.

Continue heading north on Main Street to the cemetery on the left.

4. Old North Cemetery

Opened in 1807, Old North Cemetery's monuments represent a cross-section of Hartford society in the nineteenth century. The most famous person buried in the cemetery is Frederick Law Olmsted (1822–1903). Born in Hartford, he is revered as the father of American landscape architecture. Other notable individuals buried at Old North include Daniel Wadsworth (1771–1848), founder of the Wadsworth Atheneum (see Tour 1); Reverend Horace Bushnell (1802–1876), famed Congregational minister and theologian; Nathaniel Terry (1768–1844), congressman and mayor of Hartford; James H. Ward (1806–1861), who helped establish the Naval Academy at Annapolis and was the first U.S. naval officer killed during the Civil War; Dr. Eli Todd (1769–1833), first director of the Hartford Retreat for the Insane (see Tour 5); Calvin Day (see Tour 10); and Mary Beecher Perkins (1805–1900), the sister of Harriet Beecher Stowe (see Tour 10). There are also numerous graves of African American soldiers who served in the Civil War, including many from Connecticut's all-black Twenty-ninth Infantry Regiment. The cemetery has deteriorated through many years of neglect, but there has been a recent effort by the city to make improvements.

5. Widows' Homes
1846 and 1850 Main Street

Across the street from Old North Cemetery are two buildings built in 1864–65 as an act of private philanthropy. Brownstone plaques on the buildings give the name of Lawson C. Ives, a manufacturer and member of the Pearl Street Congregational Church, who provided for their construction in his will.

6. Union Baptist Church
1921 Main Street

Next to Old North Cemetery is a church built in 1871 as St. Thomas Episcopal Church. The Gothic building, designed by Henry Martyn Congdon, has been home to Union Baptist Church since 1925. Founded in 1867 by a group of former slaves from Essex County, Virginia, the church's first house of worship was a railroad boxcar on Spruce Street. Under the leadership of Reverend John C. Jackson, who began his ministry at the church in 1922, Union Baptist made important contributions to the early civil rights movement. Church member C. Edythe Taylor became the first African American teacher in the Hartford public school system, and Reverend Jackson helped found what is now the Connecticut Commission on Human Rights and Opportunities.

Turn left on F.D. Oates Avenue (Mahl Avenue). Developer Frederick Mahl bought land on the old Mather farm (the Mather Homestead is at 2 Mahl Avenue) and built the houses here between 1893 and 1898.

7. Marietta Canty House
61 F.D. Oates Avenue (Mahl Avenue)

Marietta Canty (1905–1986) was an African American actress who appeared in theater, radio, motion pictures and television from the 1930s to the 1950s, including such films as *Father of the Bride* (1950) and *Rebel Without a Cause* (1955). On the left side of the street is a house purchased by her father, Henry Canty, in 1930. Marietta Canty lived here after her retirement from acting in 1955 to care for her father. She also continued her social and political activism, for which she received many awards.

Turn left on Bethel Street and left on Mather Street. There is a park on the right, between Mather Street and Seymes Street.

8. Lozada Park

Seyms Street was once home to the Hartford County Jail, also called the Seyms Street Jail. A High Victorian Gothic structure, it was built in 1873 to designs by George Keller. Subsequently expanded, it ceased operation as a jail in 1977 and was finally demolished the following year. The site then became a park named in honor of Julio Lozada. On May 16, 1979, twelve-year-old Julio became trapped in the collapse of a dilapidated garage on nearby Center Street. He remained trapped for some time because emergency responders did not know Spanish and could not understand what neighborhood residents were telling them. Lozada later died of his injuries. This tragic incident led the city's fire department to increase the number of Spanish-speaking firefighters. One of the new firefighters was Edward Casares Jr., who later became Hartford's first Latino fire chief in 2010.

Continue on Mather Street and turn left on Main Street. Continue north on Main Street to the church on the right, opposite the entrance to Spring Grove Cemetery.

9. Faith Congregational Church
2030 Main Street

The Talcott Street Congregational Church was founded in the 1820s by African Americans who rejected being assigned seats in the rear of white churches. The original church was built in 1826 at the corner of Talcott and Market Streets downtown. An early minister of the church was James W.C. Pennington, who had escaped slavery in Maryland. Reverend Pennington feared being dragged back to slavery after the passage of the Fugitive Slave Law of 1850, until lawyer John Hooker (see Tour 10) purchased his freedom from the estate that claimed ownership of him.

The Talcott Street Church merged with Mother Bethel Methodist Church in 1953 to form Faith Congregational Church and moved the following year to this church building on Main Street. It had been built in 1871 as the Windsor Avenue Congregational Church. One of its ministers (from 1883 to 1890) was Charles E. Stowe, son of Harriet Beecher Stowe.

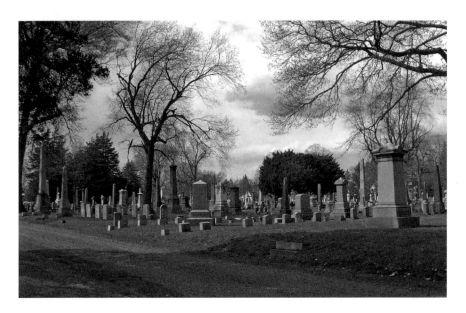

Spring Grove Cemetery. *Author photo.*

10. Spring Grove Cemetery
2035 Main Street

Spring Grove is a private cemetery founded in 1845 by Stephen Page. Notable individuals interred here include landscape painter Frederick Edwin Church (1826–1900), poet Lydia Sigourney (1791–1865), composer Henry Clay Work (1832–1884), educator of the deaf Laurent Clerc (1785–1869) and William Henry Jackson, Hartford's first African American firefighter.

11. Metropolitan African Methodist Episcopal Zion Church
2051 Main Street

This church was built next to Spring Grove Cemetery in 1874 as the North Methodist Episcopal Church. Later owned by Emmanuel Synagogue, it was

purchased in 1926 by the Metropolitan AME Zion Church, which had split from what is now Faith Congregational Church in 1833.

Turn left on Capen Street.

12. Haley Manors
36–48 Capen Street

These three six-unit buildings—one built in about 1875 and two later structures built in 1898—were rehabilitated in 1982. They are named Haley Manors after Alex Haley, the author of *Roots*.

Turn right on Clark Street.

13. St. Michael's Roman Catholic Church
7 Clark Street

Designed by Irish American architect John J. Dwyer and built in 1900 for an Irish American constituency, St. Michael's today serves a predominantly African American and Latino congregation.

Continue on Clark Street and turn left on Nelson Street. Turn right onto Barbour Street and continue north.

14. Clark and Bell Funeral Home
319 Barbour Street

This house, built in about 1875 by farmer John Clark, was enlarged in 1915, when the Women's Aid Society opened a shelter here. Since the 1950s, it has been the Clark and Bell Funeral Home, established by John C. Clark Jr., who in 1955 became the first African American to serve on the Hartford City Council.

15. Hartford Circus Fire Memorial
350 Barbour Street

Across from the Clark House is the Fred D. Wish Elementary School. Head north on Barbour Street to the school's second driveway, which heads to the rear of the building. Located behind the school is a memorial commemorating the worst disaster in Hartford's history and one of the deadliest fires in the history of the United States. On July 6, 1944, seven thousand people had gathered here under the big top for an afternoon performance by the Ringling Brothers and Barnum & Bailey Circus.

A fire started, and the flames spread quickly, aided by the paraffin and gasoline mixture used to waterproof the tent. Many victims were trampled as panic spread. The burning tent collapsed in about eight minutes, trapping hundreds beneath it; 168 people were killed, including many children, and hundreds more were injured. The most well-known victim of the fire was a blonde girl in a white dress named "Little Miss 1565" after the number assigned to her body at the morgue. It took many decades until her true identity was determined.

Dedicated on July 6, 2005, the Circus Fire Memorial marks the site of the disaster, with the location of the center ring marked by four granite benches and a bronze disk bearing names of the victims and their ages. Flowering dogwoods mark the edges of the tent, and narrative plaques give a timeline of the tragic events.

The entrance to Keney Park. *Tomas Nenortas.*

Continue up Barbour Street and turn left on Tower Avenue. At Tower, Barbour Street intersects with an entrance to Keney Park. Follow Tower Avenue to Coventry Street and turn left. Follow Coventry to Vine Street and turn right. Vine Street becomes Holcomb Street. The next stop is at the corner of Holcomb Street and Ridgefield Street.

16. Stick Style Cottage
121 Holcomb Street

This appealing cottage, built in about 1875, is a notable example of Victorian Stick-style architecture, featuring decorative half-timbering known as stickwork.

17. Oak Hill School
120 Holcomb Street

Built in 1911 as a school for the blind, Oak Hill was designed by the firm of Andrews, Jacques & Rantoul. Today, Oak Hill provides a full range of services covering the needs of a spectrum of intellectual, developmental and physical disabilities.

Turn left on Blue Hills Avenue and take the next left onto Colebrook Street. The next house is on the right side of the street.

18. Thirman Milner House
19 Colebrook Street

This was home to Thirman Milner, who was Hartford's first African American mayor and the first popularly elected black mayor in New England, serving from 1981 to 1987. It is a Colonial Revival–style house, designed by Berenson & Moses and built in 1927.

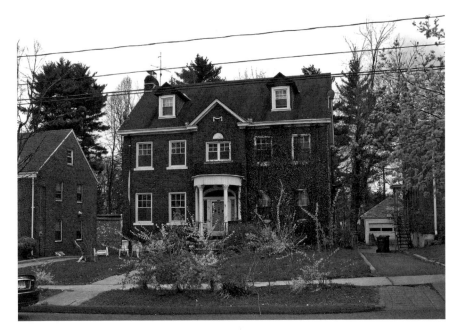

Thirman Milner House. *Author photo.*

Turn right on Ridgefield Street and take the third right onto Plainfield Street. Take the next left onto Canterbury Street.

19. Boce W. Barlow Jr. House
31 Canterbury Street

Built in 1926, this was the home of Boce W. Barlow Jr. (1915–2005), an attorney and leader of Hartford's black community. He became the first African American in the Connecticut judiciary and, in 1966, was the first to be elected a state senator.

At the end of Canterbury Street, turn left onto Westbourne Parkway. Take the next left onto Ridgefield Street. Facing Keney Park, Ridgefield has many notable early twentieth-century houses. Turn left on Plainfield Street, this time passing by Canterbury Street to turn left onto Blue Hills Avenue. St. Justin Church is on the left side of the Avenue.

20. St. Justin Roman Catholic Church
230 Blue Hills Avenue

Designed by the firm of Whiton & McMahon, St. Justin Church is an impressive example of the Art Deco style. With a background in civil engineering, St. Justin's founding pastor, Father Francis P. Nolan, was quite involved in the planning of this church. It was built in 1931–33, adjacent to Father Nolan's own house, built in 1914, which now serves as the parish rectory.

Continue on Blue Hills Avenue until it intersects with Albany Avenue and turn left. Look for a nineteenth-century brick and brownstone building surrounded by much more recent structures.

21. Northwest District School
1240 Albany Avenue

This building is all that remains of Hartford's large Northwest District School. Beginning with just two rooms in 1870, the school was vastly enlarged, with additions in 1885, 1899, 1905, 1910 and 1915. All but this 1891 section were demolished in 1978. This building will soon be the home of the John E. Rogers African American Cultural Center, which will serve as a historical and educational institution for research.

Take the next left onto Woodland Street, which ends at another entrance to Keney Park.

22. Keney Park

Henry Keney's will provided the funds for this 693-acre park, one of the largest municipal open spaces in New England. Charles Eliot, of the Olmsted Brothers firm, created a design for the park in 1898 that divided it into four separate components, each representing a typical regional landscape. The goal was to make these settings appear absolutely natural, although in reality more than half a million yards of earth were moved and millions of trees

and shrubs planted to create the park. The different sections were linked with walks and carriage drives. Keney Park's Woodland Street entrance leads into the section originally called "West Open," an open meadow surrounded by woods, with a small man-made pond.

Head east on Greenfield Street.

23. Emmanuel Synagogue
500 Woodland Street

On the corner of Woodland Street and Greenfield Street is a former synagogue that is now Faith Seventh Day Adventist Church. Designed by Ebbets and Frid, Emmanuel Synagogue was built in 1927 by Connecticut's first Conservative congregation, which had formed in 1919. The congregation moved to West Hartford in 1970.

Just down Greenfield Street on the right is another synagogue, at 221 Greenfield Street, built in 1928 by Congregation Agudas Achim, an Orthodox Jewish congregation founded in 1887 by immigrants from Romania. The congregation moved to West Hartford in 1969. The former synagogue, designed by Berenson & Moses, is now Glory Chapel International Cathedral.

Turn right onto Oakland Terrace and then left onto Albany Avenue. Continue down Albany many blocks and turn right onto Magnolia Street, which is lined with many two-family "Double Decker" houses. Turn right onto Homestead Avenue and take the next right onto Burton Street. The next house is on the left.

24. Isidor Goldberg House
35–37 Burton Street

This is a particularly grand Double Decker house, built in 1912. It was home to Isidor Goldberg, president of the Goldberg-Castonguay Coal Company. A little farther, at 54 Burton Street, is a notable house designed by architect William H. Scoville.

Continue to the intersection with Albany Avenue, which is dominated by a large church.

25. Horace Bushnell Congregational Church
23 Vine Street

In 1913, Hartford's Fourth Congregational Church moved from Main Street to this new location on Albany Avenue, naming its new church after the city's famous theologian Horace Bushnell. Architect William F. Brooks urged the congregation to save the mighty steeple and columned portico from its old church, built in 1850, and incorporate them into the new church. Today, this church is home to Liberty Christian Center International.

Just north of the church, at 47 Vine Street, is a house built in 1915. It was most likely designed and constructed by its first owner, Charles B. Andrus, who was a local builder.

From Burton Street, turn right on Albany Avenue. Continue to Garden Street and turn left. There is a synagogue on the right.

26. Beth Hamedrash Hagdol
370 Garden Street

An Orthodox Jewish congregation, Beth Hamedrash Hagdol was organized on Hartford's East Side by eastern European immigrants in 1905. This building, which became known as the Garden Street Synagogue, was completed in 1922 to the designs of Berenson & Moses. In the 1960s, the congregation merged with Ateres Kneset Israel to form the United Synagogues of Greater Hartford and moved to West Hartford. This building is now home to the Greater Refuge of Christ.

Continue on Garden Street and turn left on Mather Street, left on Irving Street and then left on Albany Avenue. Continue on Albany back to the intersection with Main Street where this tour began. Continue on Main Street and turn right on Pleasant Street. Turn right on North Chapel Street

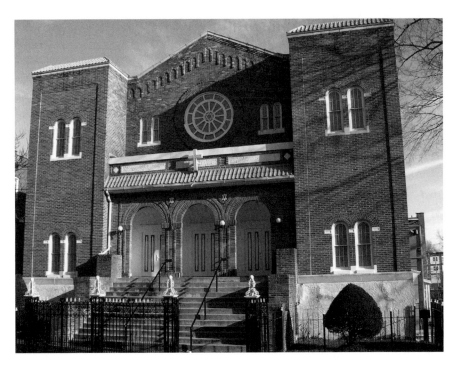

Beth Hamedrash Hagdol. *Author photo.*

and then take an immediate right around the corner onto Ann Uccello Street. The next house is on the right.

27. Arthur G. Pomeroy House
490 Ann Uccello Street

Arthur G. Pomeroy was a wealthy tobacco leaf grower from Suffield, north of Hartford. He built this elaborate Queen Anne/High Victorian Gothic house in 1882, at a time when other upper middle-class homes lined Ann Street.

Continue up Ann Street toward the Main-Albany intersection and make a sharp left around the corner (marked by a flatiron-type building) onto High Street. Continue to the house on the right, at the intersection with Walnut Street.

Isham-Terry House. *Author Photo.*

28. Isham-Terry House
211 High Street

This is one of only two surviving houses on what was once a residential block. A fine Italianate residence, the Isham-Terry House was built in 1854 for Ebenezer Roberts, a partner in the Keney brothers' wholesale grocery firm. The tower was added later in the century. In 1896, it was bought by Dr. Oliver K. Isham, who used it as both his home and doctor's office. Dr. Isham lived with his sisters, Julia and Charlotte, who resided here until their deaths in the 1970s. The house is now a museum, owned by Connecticut Landmarks. The sisters made few changes or modernizations, so the house is preserved virtually unaltered with original furnishings and Dr. Isham's undisturbed office.

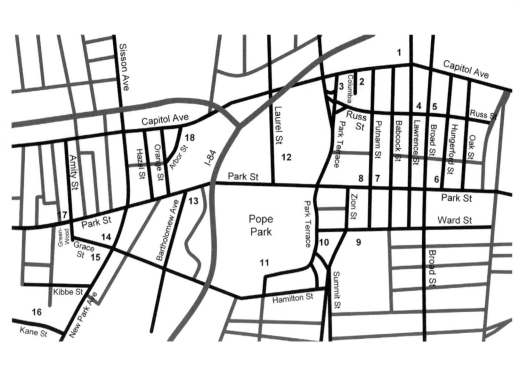

TOUR 9

Frog Hollow and Parkville

This tour presents a driving tour of two former industrial neighborhoods. Park Street is the main commercial thoroughfare through the neighborhoods of Frog Hollow and Parkville. Frog Hollow got its name from the marshy areas along the Park River, which once bounded the neighborhood on the north before being put underground due to frequent flooding. Beginning in 1852, when the Sharps Rifle Manufacturing Company established a factory here, Frog Hollow developed into a major industrial area. In the 1870s, the Sharps buildings were acquired by the Weed Sewing Machine Company, which was later bought out by industrialist Colonel Albert Pope. The Pope Manufacturing Company continued Weed's production of Columbia bicycles and developed the Columbia Electric Stanhope automobile in 1897. Pope focused on electric vehicles, but Detroit ended up dominating the industry with gasoline-powered automobiles. Pope died in 1909, and his company filed for bankruptcy in 1915. Many former Pope buildings were sold to the Pratt & Whitney Machine Tool Company.

By the 1950s, most of Frog Hollow's factories had shut down, but the neighborhood has numerous buildings that survive from the booming days of the nineteenth century. Many immigrant groups have made Frog Hollow their home. Today, it is a center of Hispanic culture.

Passing under Interstate 84, Park Street enters the Parkville neighborhood, which was named for its location at the junction of the North and South branches of the Park River. In 1878, residents tried to secede from

Hartford, arguing that the then undeveloped area was being overtaxed. By the 1890s, however, Parkville followed Frog Hollow's development as an industrial area. With a significant Portuguese American population, this compact, triangular-shaped neighborhood is today home to a vibrant multiethnic community, with many thriving Latino, southeast Asian and Brazilian businesses.

Head west on Capitol Avenue, past the state capitol building and state armory, to the former factories on the Avenue's north side, beyond the intersection with Broad Street.

1. Capitol Avenue Factories

Many of the Frog Hollow manufacturers described here occupied these factories in the second half of the nineteenth century. The buildings have been much altered over the years and are now used as offices. Intersecting Capitol Avenue are Babcock, Putnam and Columbia Streets, where housing for the factories' workers was built.

2. Columbia Street Houses

The row houses on Columbia Street, which ends in a cul-de-sac, are especially notable because they were designed by Hartford architect George Keller. The street was opened by the Weed Manufacturing Company and named for the Columbia bicycle. For the east row (constructed in 1888) and west row (constructed in 1889), Keller created a series of individual but connected residences.

Continue west on Capitol Avenue and turn left on Park Terrace, just before Capitol Avenue passes under Sigourney Street and the highway.

3. Park Terrace Houses

George Keller also designed these row houses on Park Terrace, which were built in 1895. For his fee, Keller received the house at the south end of this row, where he lived the rest of his life.

Turn left on Russ Street and drive to the intersection with Lawrence Street.

4. Billings & Spencer Company
539 Broad Street

The northeast corner of Russ and Lawrence Streets is dominated by the Romanesque Revival tower of the former Billings & Spencer Company factory. Charles Billings and Christopher Spencer were former employees

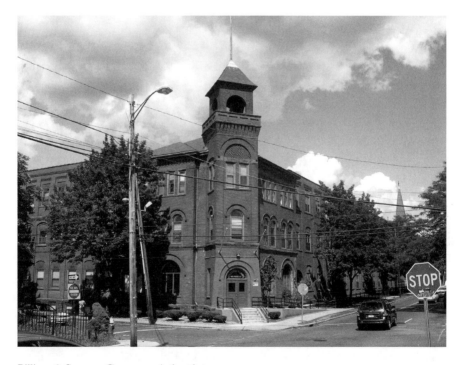

Billings & Spencer Company. *Author photo.*

at the Colt Armory who started their own drop-forging shop here in 1872. The current complex of buildings was built in 1893. They are now home to Billings Forge Community Works, a nonprofit organization.

Continue on Russ Street to the church at the intersection with Broad Street.

5. Swedish Bethel Baptist Church
110 Russ Street

Originally built in 1890 as the Swedish Bethel Baptist Church, this church later became St. Volodymyr's Ukrainian Orthodox Church. There were other Scandinavian churches in the neighborhood, including the Swedish Zion Congregational Church, the Swedish Evangelical Lutheran Emanuel Church and Our Saviour's Danish Evangelical Lutheran Church.

Turn right on Hungerford Street, pass through the intersection with Grand Street and turn right on Park Street.

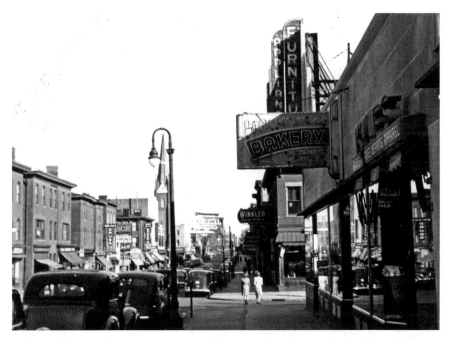

Park Street in Frog Hollow, October 1944. Photo by A.S. DeBonee. *Hartford History Center, Hartford Public Library.*

6. Immaculate Conception Church
560 Park Street

On the right is Immaculate Conception Church, designed by Michael O'Donohue. It was built in 1894 to serve the many Roman Catholic immigrant factory workers who were moving to Frog Hollow. In 2000, Immaculate Conception merged with St. Anne Parish. The church building is now used by the Immaculate Conception Shelter & Housing Corporation, established in 1990.

Continue west on Park Street to the church on the right, just before the intersection with Putnam Street.

7. St. Anne Church
784 Park Street

This Roman Catholic church was established to serve Hartford's French Canadian population. The first St. Anne's Church on this corner was dedicated in 1893 and was later replaced by the current church, designed by Henry F. Ludorf and dedicated in 1926. St. Anne Parish merged with Immaculate Conception Parish in 2000.

8. Watkinson School
820 Park Street

On the other corner of Park Street and Putnam Street is a structure built in 1884 as a dormitory by the Watkinson Juvenile Asylum and Farm School. It is now the rectory of St. Anne's Church.

Continue on Park Street and take the next left onto Zion Street. At the southeast corner of Zion Street and Ward Street is the entrance to a cemetery.

9. Zion Hill Cemetery

Many of Hartford's prominent citizens were buried in Zion Hill Cemetery, established in 1844. The cemetery is in an elevated area, being at the northern end of Gallows Hill.

Turn right on Ward Street and left on Park Terrace. Immediately on the left is a row of multifamily dwellings facing Pope Park.

10. Park Terrace Perfect Sixes
222–248 Park Terrace

The "Perfect Six" has been described as Hartford's signature type of housing. Perfect Sixes can be found throughout the city but are particularly prevalent in Frog Hollow. The neighborhood was experiencing an increase in population in the 1890s and the first decade of the twentieth century, when the majority of Perfect Sixes were being built. A Perfect Six is three stories high and designed to house six families, two on each floor. The entrance and stairs to the upper apartments are in the center of the façade between two matching bow-fronts. They were inexpensive to build and have proven durable, housing generations of families, although some have succumbed to urban decay. Preservationists have worked to rehabilitate many Perfect Sixes, including these particularly fine ones, which provide their residents a view of Pope Park below.

Follow Park Terrace to where it ends at Hillside Avenue. The entrance to Pope Park is on the right.

11. Pope Park

Colonel Albert Pope donated ninety acres to the city for a park, which was landscaped in 1898 by the Olmsted Brothers firm. The Park River was an important component of Pope Park until it was diverted underground. Also located in the park is a memorial fountain honoring Albert Pope. It was

designed by George Keller in 1913. Unfortunately, the Pope Fountain has been sadly neglected and has been inoperable for many years.

Turn around in the park's parking lot and turn left on Park Terrace. Return to Park Street and turn left. As you continue west on Park Street, there are two large apartment towers to the right.

12. The Towers at Park Place

A feature of the contemporary Hartford skyline, the Towers at Park Place were built in 1986 to the designs of Beyer Blinder Belle. The parking lot north of the Towers is the approximate location of Oakholm, the first

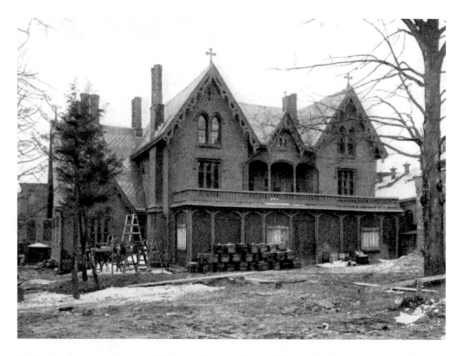

Oakholm, former residence of Harriet Beecher Stowe. When this picture was taken, it was being used as a storehouse by the Hartford Cycle Works. Oakholm was demolished in 1905. *McClure's* magazine, May 1897. *Tomas Nenortas.*

Hartford house of author Harriet Beecher Stowe (see Tour 10). Designed by Octavius Jordan and built in 1864 near the Park River, Oakholm was an outstanding example of a Gothic Revival villa. Too expensive for her to keep up, Stowe sold the house in 1870. Factories were then already beginning to encroach on Oakholm's idyllic locale. Before long, the house became surrounded by the factory of the Hartford Cycle Works that was later taken over by the Underwood Typewriter Company. Used as a storehouse, Oakholm was demolished in 1905. The Underwood factory complex grew to a substantial size but was eventually torn down.

Continuing on Park Street, pass under Interstate 84 and turn left onto Bartholomew Avenue, where there are several large former factory buildings.

13. Hartford Rubber Works
1429 Park Street

Several factory buildings, constructed between 1890 and 1920, are located here along Bartholomew Avenue. They were built by the Hartford Rubber Works, which pioneered the pneumatic tire and was later bought by Colonel Albert Pope to produce tires for his bicycles and automobiles. The buildings have since been adapted to other uses.

Return to Park Street and continue west. The area around the intersection of Park Street and New Park Avenue is the center of the Parkville community. Turn left onto New Park Avenue. Past the Parkville Community School and Parkville Library are two churches on the right side of New Park as you head south.

14. Grace Episcopal Church
55 New Park Avenue

Grace Church was established as a mission of Trinity Church (see Tour 10) in 1863 and became an independent parish in 1912. The original wooden chapel of 1868 is now hidden behind the current brick exterior, completed in 1967. George Keller designed a parish house for the church in 1898.

15. Our Lady of Sorrows Church
79 New Park Avenue

Begun as a mission of St. Joseph's Cathedral, with a chapel constructed on Grace Street in 1887, Our Lady of Sorrows became a parish in 1895. The Gothic Revival church, designed by O'Connell & Shaw, was built in 1921–25.

Next to Our Lady of Sorrows Church is the former seminary of the Missionaries of Our Lady of LaSalette, at 85 New Park Avenue. The mission having been founded in France in 1852, Hartford became the first city of its North American chapter in 1892. The seminary was built here in 1894, and the wings on either side were added in 1907 due to the increasing numbers of students. The last class to graduate from the Hartford Seminary was in 1961, when a new seminary opened in Cheshire. The former seminary building is now a retirement house for LaSalettes.

Continue down New Park Avenue and turn right on Kane Street. Just before the turn, a now lost Parkville landmark was once located on the east side of New Park Avenue where there is a supermarket today. The Royal Typewriter Company moved to Hartford and built a massive factory here in 1907. The company employed more than five thousand people, making Hartford not only the insurance capital but also the typewriter capital of the world. The factory shut down in the 1980s, and the vacant building was destroyed by a fire in 1992.

To see one of Parkville's most recent landmarks, look at the modern church on the right on Kane Street.

16. Church of Our Lady of Fatima
50 Kane Street

Hartford's Portuguese and Azorean population grew rapidly in the 1950s. A parish for Portuguese American Catholics was established in 1958, and the current Our Lady of Fatima Church, a building of modern design by Handler & Friar, was built in 1986–88. Walk around the church to observe how the architects designed it for this steeply sloping location.

Return to New Park Avenue and turn left. Turn left at Grace Street, which is between Our Lady of Sorrows Church and Grace Church. Turn right on Greenwood Street, which becomes Amity Street when it crosses Park Street. There is a church at the northwest corner of Park and Amity Streets.

17. St. Paul's Methodist Church
57 Park Street

Built in 1900, this church was designed by George W. Kramer in the Richardsonian Romanesque style. It has a flexible design created to occupy a relatively small urban lot. The top of the corner tower was lost in the Hurricane of 1938. In 1974, St. Paul's merged with the First United Methodist Church on Farmington Avenue. This building is now Iglesia de Dios Pentecostal.

Turn right onto Park Street and continue for several blocks. Turn left onto Orange Street. Turn right on Arbor Street.

18. Arbor Street Factories
16–34 Arbor Street

The factory building on the corner here was built in 1917 by the Hartford Industrial Development Company. It has an Art Deco entryway, added in 1927. It is now home to various tenants, including, at 56 Arbor Street, Real Art Ways, a nonprofit alternative art space established in 1975. The

next factory building on the right was built in 1913 by the Gray Telephone Pay Station Company. It was one of the first factories in Hartford to be constructed of steel and reinforced concrete.

Arbor Street intersects with Capitol Avenue. Turn right on Capitol to return to this tour's starting point.

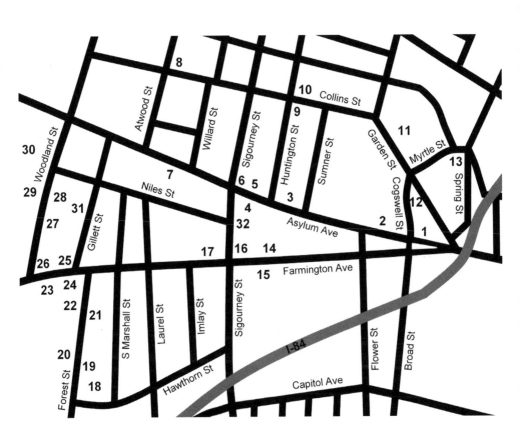

TOUR 10

Asylum Hill

H eading west from downtown Hartford, Asylum Street passes under train
tracks and an interstate highway and becomes Asylum Avenue. Just to
the west, Farmington Avenue splits from Asylum. These two thoroughfares
form the main arteries through the neighborhood known as Asylum Hill.
Asylum Avenue and Asylum Hill both take their names from the American
Asylum for the Deaf and Dumb, now the American School for the Deaf. The
Asylum's building, constructed on a hill overlooking downtown in 1821, stood
for a century before the institution was moved to a new home in West Hartford.
Farmland once dominated the area to the west, but in the mid-nineteenth
century, many of the city's most prominent families established homes here.
Asylum Hill soon developed into a fashionable residential neighborhood.

The most substantial estate in the area was Goodwin Castle, which was built
on Woodland Street between 1871 and 1874. A Gothic Revival mansion of
immense proportions, it was planned for Major James Goodwin by his son,
Reverend Francis Goodwin, who hired the architect Frederick C. Withers.
Goodwin Castle was demolished in 1940, but its restored reception room with
original furnishings can be seen at the Wadsworth Atheneum, providing a
glimpse of the lifestyles of Hartford's elite during the city's most prosperous era.

New immigration and increasing commercial development downtown
led to the migration of the wealthy. They were soon followed by many
middle-class families. By 1900, the streets of Asylum Hill were lined with
brick Victorian houses, significant numbers of which survive today. Further

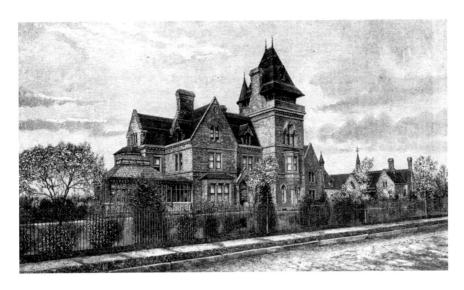

Goodwin Castle, residence of James Goodwin on Woodland Street; it was demolished in 1940. *Memorial History of Hartford County, 1886.*

development came in the early twentieth century, when some of the city's large insurance companies also moved out of downtown, building their impressive headquarters in Asylum Hill. This brought even more residents and led to the construction of new apartment buildings and commercial structures. These new buildings appeared on land that a few decades before had contained large houses occupying properties of several acres. The wealthy had once more moved westward, and many older houses were being demolished or converted to other uses. By the 1960s, interest in historic preservation led to the extensive restoration of the homes of Hartford's two most famous literary figures, Mark Twain and Harriet Beecher Stowe. Their houses were built in the 1870s in Nook Farm, a progressive section of Asylum Hill that was home to a community of influential writers, politicians and social activists.

This tour is designed for walking; those wishing to drive will have to make adjustments for busy traffic and one-way streets. The lengthy tour consists of two walking loops. Stops numbered 1 through 14 center on Asylum Avenue and its adjacent streets. The second loop (stops numbered 15 through 32) proceeds down Farmington Avenue and takes in the notable residences on Forest and Woodland Streets.

Heading west from downtown, look at the triangle formed where Farmington Avenue splits from Asylum Avenue. There is a memorial sculpture in the center of the triangle.

1. American School for the Deaf Founders Memorial

In 1807, two-year-old Alice Cogswell lost her hearing after a severe fever. Her father, Dr. Mason F. Cogswell, wanted the best education for his daughter, but no school for the deaf yet existed in the United States. In 1815, Dr. Cogswell met with other prominent men in Hartford with the aim of raising money to found a school for the deaf. Before this could be achieved, they needed to send a representative to Europe with the goal of learning the established methods of teaching the deaf. For this mission, they turned to Thomas Hopkins Gallaudet, a graduate of Yale University and Andover Theological Seminary. While in Hartford recovering from a chronic illness, Gallaudet had become convinced that Alice Cogswell, who did not know sign language, could be educated to communicate. After fruitless negotiations at the Braidwood School in England, a for-profit establishment that expected payment for sharing its techniques, Gallaudet moved to Paris, where he studied the teaching methods in use at the French Institute for the Deaf. He returned to America with the young deaf educator Laurent Clerc, an instructor at the Paris school.

The oldest existing school for the deaf in America opened in 1817 in Hartford's City Hotel on Main Street (where Bushnell Plaza is today). Gallaudet was the first principal and Clerc the first teacher, and Alice Cogswell was one of the first seven students to be enrolled. From this start, the number of students grew rapidly, with pupils coming from across the country. In 1821, the school was moved into a new building, located where The Hartford stands today. In 1921, the American School for the Deaf moved to 139 North Main Street in West Hartford.

The Founders Memorial sculpture is located near the site of the school's old Asylum Hill home. The monument, designed by Frances Wadsworth, was unveiled on April 18, 1953. It features giant hands making the sign for "light." Between the hands is the figure of a girl, based on Alice Cogswell but intended to represent all deaf children in America. She holds a book that represents the education that Gallaudet brought to the deaf.

Continue on Asylum Avenue, past the intersection with Broad Street. The next six sites are located along Asylum as you head west. The large building with the impressive columned portico on the right is the next stop.

2. The Hartford
1 Hartford Plaza

The first major insurance firm to build its headquarters on Asylum Hill is also the oldest in Connecticut. The Hartford Fire Insurance Company was established in 1810 by a group of merchants. They were led by Eliphalet Terry, who became the company's first president. After a fire in 1834 destroyed a large amount of property in Lower Manhattan, many New York insurance companies were ruined. Terry quickly arrived from Hartford having pledged his personal fortune to cover his company's damage claims. This and other similar incidents helped to spread the reputation for stability of Hartford insurance companies.

The Hartford's imposing Neoclassical building, designed by Stevenson and Dodge of Boston, was built in 1920–21. It occupies a prominent location, on a hill just northwest of where Broad Street meets Asylum Avenue. This was the very spot where the old Asylum for the Deaf and Dumb had stood before The Hartford acquired the property in 1919. Now known as the Hartford Financial Services Group, it is one the nation's largest investment and insurance companies.

3. Asylum Hill Congregational Church
814 Asylum Avenue

In 1864, a prosperous group of Asylum Hill residents organized a new Congregational church. They hired Patrick C. Keely of New York, known as a prolific architect of Catholic churches, to design the building. He created a structure in the fashionable Gothic Revival style. More commonly associated with Catholic and Episcopal churches, Gothic Revival was becoming popular at the time with other denominations. The brownstone edifice was built in 1864–65, but many more years passed before the impressive steeple was completed.

In 1868, before he settled in Hartford, Mark Twain was staying at the house of his publisher, Elisha Bliss of the American Publishing Company. The house was across the street from the still steepleless church that Twain referred to as the "stub-tailed church." He also knew of the church's prosperous membership, many of whom were involved in commercial

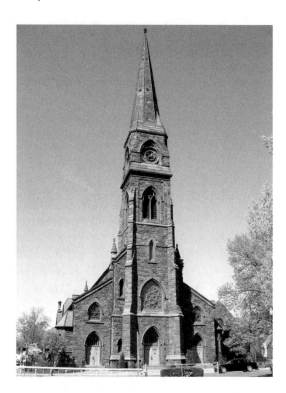

Asylum Hill Congregational
Church. *Author photo*.

ventures. During an evening reception at the Bliss home, Twain noticed a
framed photograph of the church on the wall and said, "Why yes, this is the
Church of the Holy Speculators." Mr. Bliss quickly cautioned Twain that
the church's pastor was right behind him and wanted to meet him. That
pastor was Reverend Joseph Hopkins Twichell, who would become Twain's
closest friend and frequent traveling companion.

Born in 1838, Joseph Twichell was a Yale graduate who interrupted his
seminary studies at the outbreak of the Civil War to serve as chaplain with
a regiment of mostly poor Irish Catholics in New York's Excelsior Brigade.
After the war, he became the first pastor of Asylum Hill Congregational
Church, a position he held for forty-seven years. Twichell and his friend
Samuel Clemens would often go for long walks in the neighboring
countryside sharing stories. It was a suggestion from Twichell that inspired
Clemens to write about his youthful experiences as a Mississippi River
boat pilot.

4. Linus B. Plimpton House
847 Asylum Avenue

While many of the old houses on Asylum Avenue, like the Bliss House, have been lost, a number survive and give a sense of what the street was once like. Built in 1884, the Romanesque-style Linus B. Plimpton House was designed by architect John C. Mead. In 1865, Plimpton established a business in Hartford manufacturing envelopes. In 1874, the Plimpton Manufacturing Company won an important contract to produce stamped envelops for the U.S. government, a prize awarded by Postmaster General Marshall Jewell, a Hartford native and former governor of Connecticut. The modern descendant of the old manufacturing firm continues to exist as Plimpton's, a stationery retail store at 991 Farmington Avenue in West Hartford Center. The old Plimpton House on Asylum Avenue is now used for elderly housing.

5. George A. Bolles House
852 Asylum Avenue

Across from the Plimpton House is another striking example of Asylum Hill architecture, built in about 1875. Although lacking its original front and side porches, the George A. Bolles House still displays the eclectic design features that appealed to this neighborhood's residents.

6. Asylum Avenue Baptist Church
868 Asylum Avenue

In 1872, Baptist residents of Asylum Hill followed their Congregationalist neighbors in building a church on Asylum Avenue. The large front section, designed by Hapgood & Hapgood, was added much later in 1896. The older section, designed by George Keller, is visible along Sigourney Street. Keller had heard that industrialist Jonathan S. Niles

was promising to generously fund construction of the church if it was designed to resemble a small church that he frequently passed on Forty-second Street on his visits to New York City. Keller happened to be personally acquainted with the architect of that church, who generously provided him with his own original drawings. Armed with these, Keller won the commission to design the new church.

Unfortunately, a fire gutted the Asylum Avenue Baptist Church in February 1931. What we see today is a partial reconstruction based on the original designs of 1872 and 1896.

7. West Middle School
927 Asylum Avenue

The original West Middle School of 1873 was an ornate High Victorian Gothic building designed by Richard M. Upjohn, architect of the state capitol building. When the time came to replace the old school building, architectural fashion had changed considerably. When the current building (designed by Malmfeldt, Adams & Prentice) was constructed in 1930, Georgian Revival had become a style of choice for both residences and public buildings. The school is topped by a cupola clearly modeled on that of the Old State House (see Tour 1).

Take a right on Atwood Street. On the left is the campus of St. Francis Hospital, founded in 1897. Turn right onto Collins Street.

8. George W. Flint House
310 Collins Street

At the corner of Atwood and Collins Street, the 1895 house of George Flint is transitional in style, reflecting the changing architectural tastes of its era. A Queen Anne tower is nestled between two large Tudor Revival gables.

9. George H. Seyms House
181 Collins Street

Note the High Victorian Gothic details on this house, which may have been the work of architect George Keller. George H. Seyms was a chemist who worked for the Hartford Steam Boiler Insurance and Inspection Company. He also served for many years as water commissioner for the city.

10. Joseph W. Cone House
182 Collins Street

Across from the Seyms House is a brick Queen Anne residence that, like the Bolles House, has lost its Victorian-era front porch. Joseph W. Cone worked for the Aetna Insurance Company.

Continue on Collins Street and turn right on Garden Street.

11. Connecticut Mutual Life Insurance Company
140 Garden Street

Another Hartford insurance firm that moved to Asylum Hill in the early twentieth century was the Connecticut Mutual Life Insurance Company. Long successful with fire insurance, conservative Hartford had a slow start in the life insurance business due to a puritan aversion to the practice. Eventually, Connecticut Mutual Life was incorporated in 1846. Its Classical Revival headquarters on Garden Street, designed by Benjamin Wistar Morris, was completed in 1926. The company merged with MassMutual in the 1950s. The building once had wings that were recently demolished. Today, it is owned by The Hartford.

Proceed down Garden Street and take a right on Cogswell Street.

12. Caledonian-American Insurance Company
150 Cogswell Street

Another insurance company building now owned by The Hartford is the former headquarters of the Caledonian-American Insurance Company, a Scottish firm. The classical revival design of the 1936 building is by architect Carl J. Malmfeldt.

If you want to shorten this tour, you can continue down Garden Street back to Asylum Avenue and skip the next stop or make an extra loop to see it. To get there, take a left on Myrtle Street and a left on Spring Street to the Italianate-style house on the corner.

13. Calvin Day House
105 Spring Street

The lone survivor of what was once a residential area overlooking downtown, this house was built in 1852 for Calvin Day, partner in a wholesale dry goods firm. Calvin Day was a descendant of Robert Day, who came to Hartford in 1636 with Reverend Thomas Hooker. Calvin Day's son, John Calvin Day, married Alice Hooker, the daughter of lawyer John Hooker (himself a descendant of Thomas Hooker) and his wife, Isabella Beecher (the half sister of Harriet Beecher Stowe).

Keep to the right on Spring Street as it curves to intersect with Garden Street. Cross to the other side of Garden Street and follow it as it intersects with Asylum Avenue. Turn right on Asylum. To begin the second loop of this tour, turn left on Broad Street and proceed down Farmington Avenue. Stop nos. 14–17 are along Farmington.

14. Cathedral of Saint Joseph
140 Farmington Avenue

One of the most recognizable modern landmarks of Asylum Hill is the spire of the Cathedral of Saint Joseph, which rises 281 feet from the sidewalk.

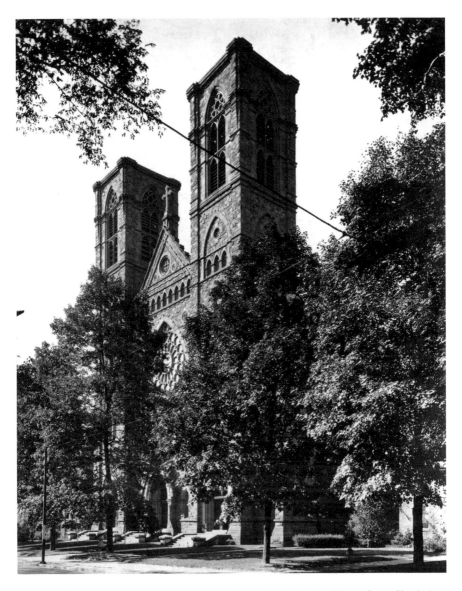

Saint Joseph's Cathedral; it was destroyed in a fire in 1956. *Hartford History Center, Hartford Public Library.*

The mother church of the Catholic Archdiocese of Hartford, the cathedral was dedicated on May 15, 1962. Designed by Eggers and Higgins of New York, it is a boldly modern interpretation of Gothic exemplars, constructed of reinforced concrete with an exterior of Alabama limestone. The beautiful

windows of the main nave, 67 feet high and 13½ feet wide, were designed by Jean Barillet of Paris.

The current cathedral stands on the site of the old St. Joseph's cathedral designed by Patrick C. Keely and built between 1876 and 1892. It was destroyed in one of Hartford's worst fires. Worshipers at the 7:00 a.m. morning mass on December 31, 1956, began to notice the smell of smoke. Deputy Fire Chief James McSweegan, who was attending the mass, soon pulled the alarm. Arriving firefighters had difficulty at first locating the source of the burning smell because the fire was building up in the gaps between the wooden walls and brownstone exterior. Eventually, flames began to engulf the interior, and the treasured stained-glass windows shattered from the heat. Firefighters, some overcome by the smoke, scrambled out when flames appeared along the ceiling. The roof fell, leaving the great Gothic edifice a smoldering ruin. Disturbingly, just the day before, another fire had ravaged the interior of St. Patrick's Church on Church Street (see Tour 2). St. Patrick's was restored, but the archdiocese decided to replace St. Joseph's with the current cathedral.

15. Aetna Building
151 Farmington Avenue

The Aetna Life & Casualty Company was incorporated in 1853 as an offshoot of the older Aetna Fire Insurance Company. Regulations at the time prevented the same company from selling both fire and life insurance. Since then, Aetna Inc. has grown into one of the largest health insurance companies in the United States. For Aetna's Farmington Avenue home office, built in 1929–31, architect James Gamble Rogers created a truly massive Colonial Revival building. The design makes an impression of great size linked to old American tradition, with a cupola inspired by the Old State House downtown. To compensate employees for the move away from the conveniences of downtown to the residential Asylum Hill, the building provided such amenities as a retail store, a library, bowling alleys and squash, tennis and basketball courts.

In 2000, Aetna released a public apology for its practice in the 1850s of insuring the lives of slaves with policies benefiting slave owners.

16. Ahern Funeral Home
180 Farmington Avenue

Built in about 1855, this house combines elements of the Greek Revival and Italianate styles of architecture. Since 1934, the house has been the Ahern Funeral Home, founded in 1886.

17. Ambassador Apartments
208 Farmington Avenue

The elegant Ambassador Apartments were built in 1919–21 during a boom in Asylum Hill apartment construction. Workers were following the movement of large insurance companies into the area. The Renaissance Revival building, designed by Berenson and Moses, utilizes a U-shaped plan that provides the apartments with the greatest number of windows possible to provide natural light.

Continue down Farmington Avenue and turn left on Forest Street. This is the beginning of an area that was known as Nook Farm in the nineteenth century. The homes of Nook Farm's two most famous residents, Mark Twain and Harriet Beecher Stowe, are now museums open to the public. The parking lot of the Mark Twain House and Museum is farther down Farmington Avenue, while the smaller parking lot of the Harriet Beecher Stowe Center is on the right on Forest Street.

Walk down Forest Street, passing a number of buildings to be discussed soon. A group of 1950s-era apartment buildings is located just before Hawthorn Street intersects on the left. A driveway between the buildings leads to a Victorian Gothic house, mostly hidden from view behind the later structures.

18. John and Isabella Beecher Hooker House
140 Hawthorn Street

In 1853, John Hooker and his brother-in-law, Francis Gillette, purchased 140 acres here from William H. Imlay. An area of pasture and woodland

on the edge of the expanding city, it was called Nook Farm because it was bounded to the west by a large bend, or "nook," in the Park River. Hooker and Gillette opened Forest Street and began to sell lots to family and friends. Nook Farm quickly developed into a neighborhood of comfortable Victorian houses in a parklike setting that became home to some of Hartford's most accomplished and progressive residents.

John Hooker (1816–1901), a descendant of Thomas Hooker, was a prominent attorney and the reporter of judicial decisions of the state Supreme Court, a position he held for thirty-six years. His wife, Isabella Beecher Hooker (1822–1907), was the younger half sister of Harriet Beecher Stowe. After the Civil War, Isabella dedicated herself to the cause of women's suffrage, lobbying Congress in Washington, D.C., and planning women's rights conventions throughout the state. She was closely associated with such leaders of the suffrage movement as Elizabeth Cady Stanton and Susan B. Anthony, as well as the more radical Victoria Woodhull. Aided by her husband's legal knowledge, Isabella presented to the state legislature a bill to give married women equal property rights with their husbands. She reintroduced the bill annually for seven years until it passed in 1877.

The Hooker House was built in 1853 but was enlarged and embellished in the fashionable Gothic Revival style in 1861 by architect Octavius Jordan. John Hooker's widowed mother, Elizabeth Daggett Hooker, lived in a small cottage on the Hooker property. Mark Twain and his family leased the Hooker House from 1871 until 1874, until his own residence was completed nearby. The house was significantly altered in 1906, when the Merrow family raised the entire structure to add an additional floor. A change in the color of the bricks, visible on the side of the house, marks this alteration. Today, the house is used for apartments.

The Hooker House once faced another Victorian cottage in what is now a fenced-off and overgrown area on the other side of Hawthorn Street. It was rented by Joseph R. Hawley from 1861 to 1867. Married to Harriet Foote, a cousin of Isabella Beecher Hooker, Hawley was a leader of the Free-Soil Party in the 1850s, and he ended his service in the Civil War as a major general. He was governor of Connecticut from 1866 to 1867 and later served in the U.S. House and Senate.

Another house that is lost to us today stood on the property next to the Hawley House. Designed by Octavius Jordan, it was from 1855 to 1866 the residence of Isabella's older half sister, Mary, and her husband, Thomas Clapp Perkins. It was next the home of author Charles Dudley Warner before he

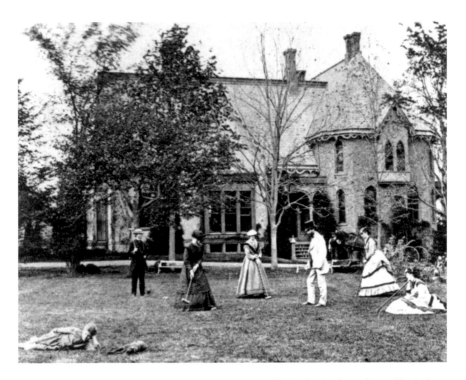

John and Isabella Beecher Hooker House, circa 1870. *Harriet Beecher Stowe Center, Hartford, Connecticut.*

moved farther up the street. Its most famous association came in the twentieth century, when from 1908 to 1917 it was home to Dr. Thomas Hepburn, the first doctor in New England to specialize as a urologist, and his wife, women's rights activist Katharine Houghton Hepburn. The second of their six children was Katharine Hepburn, the movie star, who grew up in the house.

Retrace your steps back up Forest Street.

19. Burton House Site
36 Forest Street

This house was built in 1895, but a previous home on the property was rented for several years by Reverend Nathaniel Burton. An intimate of the

Nook Farm circle, Reverend Burton was a pastor for many years in Hartford, first at the Fourth Congregational Church and then at the Park Church. His brother, Henry, was married to John and Isabella Beecher Hooker's daughter, Mary.

20. Hartford Public High School
55 Forest Street

The second-oldest secondary school in the United States (after the Boston Latin School), Hartford High's history goes back to 1638, when Thomas Hooker founded a school to prepare young men for college. By the 1700s, it was known as the Hartford Grammar School. The school's classical course was joined by a new English course in 1847, and the resulting institution was named the Hartford Public High School. The school moved to a Gothic building in Asylum Hill in 1869. Destroyed by fire in 1882, it was replaced by an even grander structure, designed by George Keller. Located on Hopkins Street, the school was enlarged in 1897, with additional buildings being constructed for manual training in 1899 and business and industrial courses in 1914. This substantial educational complex was sadly destroyed in the 1960s to make way for Interstate 84. The high school was moved here to Forest Street, where the current building opened in 1963.

Construction of the new school required the demolition of many Nook Farm houses that had once dotted the west side of Forest Street. The most significant were the Gillette and Warner Houses.

Francis Gillette (1807–1879), an abolitionist who served from 1854 to 1855 in the U.S. Senate, was married to John Hooker's sister, Elizabeth. Together with his brother-in-law, Gillette was one of the original developers of Nook Farm. He and his family lived for a time in an old farmhouse on his property (where his sixth child, William, was born in 1853) before building his own house. Gillette also built a barn, which is said to have been a station on the Underground Railroad that aided fugitive slaves in their quest to reach freedom. Francis Gillette's son, William Gillette, grew up to become an actor and playwright. He was most famous for his stage portrayals of Sherlock Holmes, in which he popularized the character's association with the deerstalker cap. Gillette later built a fantastical home along the Connecticut River in east Haddam. It can be visited by the public at Gillette Castle State Park.

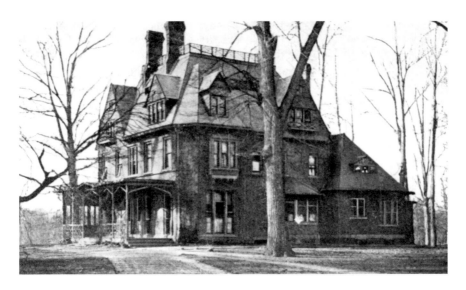

Warner House. *Tomas Nenortas.*

Francis and Elizabeth Hooker Gillette's daughter, Lilly Gillette, married George H. Warner in 1867. The two built their own Nook Farm residence in 1873, a High Victorian Gothic house designed by Edward Tuckerman Potter, who would go on to be the architect of the Mark Twain House. In 1884, George and Lilly moved into the old Gillette home next door and sold their house to George's brother, Charles Dudley Warner. He moved in with his wife, Susan Lee Warner, a talented pianist and patron of music in Hartford.

Charles Dudley Warner (1829–1900) had been invited to Hartford in 1860 by Joseph Hawley to become associate editor of the *Hartford Evening Press.* After 1867, he was editor of the *Harford Courant.* Known during his lifetime for his travel books, Warner also wrote a series of sketches relating his gardening efforts in Nook Farm, which were collected in the 1870 book *My Summer in a Garden.* He is best remembered today for his co-authorship with Mark Twain of the novel *The Gilded Age,* which was written while Twain was renting the Hooker House and Warner lived in the Perkins House. One evening, when Twain and Warner spoke critically of the novels being discussed by their wives, they were challenged by the women to come up with a better one themselves. The resulting novel was written between February and April 1873.

21. Charles Smith House
66 Forest Street

This brick Gothic house, built in 1875 for Charles Boardman Smith, was designed by Richard M. Upjohn, architect of the state capitol building (see Tour 3). Smith was a partner in Smith, Bourn & Company, which had been making horse saddles since 1794. Now known as the Smith-Worthington Saddlery Company, it is still in business at 275 Homestead Avenue in Hartford.

22. Harriet Beecher Stowe House
77 Forest Street

In 1871, lawyer and real estate developer Franklin Chamberlin built two nearly identical Gothic cottages on Forest Street. He sold one to his law partner Ezra Hall in 1872. Demolished in the 1960s, it stood where the Harriet Beecher Stowe Center's parking lot is today. The other house was sold in 1873 to Harriet Beecher Stowe, who had sold her earlier Hartford house, Oakholm, in 1870 (see Tour 9).

Born in Litchfield, Connecticut, in 1811, Harriet Beecher Stowe came from a well-known family of congregational ministers. Her father, Lyman Beecher, and all seven of her brothers were preachers, including the famous Henry Ward Beecher. Her husband, Calvin Stowe, was also ordained as a minister. A professor and biblical scholar, he wrote *The Origin and History of the Books of the Bible*, published in 1867.

Harriet's connections with Hartford began in the 1820s, when she attended and later taught at the Hartford Female Seminary, run by her older sister Catharine (see Tour 2). Harriet Beecher Stowe would achieve fame with the publication in 1852 of her best-selling antislavery novel, *Uncle Tom's Cabin*. She wrote the book while living in Brunswick, Maine, where her husband was teaching at Bowdoin College. For the next thirty years, Stowe continued to write in a variety of genres: novels, stories, accounts of her travels and domestic advice.

After Stowe's death in 1896, her Forest Street house passed through other owners. It was acquired in the 1920s by Katharine Seymour Day (1870–1964), the granddaughter of Harriet Beecher Stowe's sister, Isabella Beecher

Hooker. Day established what is now known as the Harriet Beecher Stowe Center, which restored the Stowe House after her death and opened it to the public in 1968. The Stowe Visitor Center is located just beyond the parking lot in a former carriage house built by Franklin Chamberlin in 1871 (note the initials "FC" on the side of the building).

Across the lawn behind the Stowe House is the extraordinary structure known as the Mark Twain House.

23. Mark Twain House
351 Farmington Avenue

Samuel Langhorne Clemens, born in 1835, first came to Hartford in 1868 to meet with his publisher, Elisha Bliss Jr. of the American Publishing Company. Under the pen name Mark Twain, Clemens achieved notoriety as a reporter in California, and his story "The Celebrated Jumping Frog of Calaveras County" achieved national popularity. *The Innocents Abroad*, a humorous account of his travels in Europe and the Middle East, was published in 1869 and became a bestseller. The following year, he married Olivia Langdon, of Elmira, New York. Called Livy, she was the daughter of a wealthy businessman who had made his fortune in coal. Clemens's father-in-law bought the couple a house in Buffalo, New York, but in 1871 Clemens moved his family to Hartford to be closer to his publisher. At first, they rented the Hooker House but, in 1873–74, built their own home on Farmington Avenue. It is said that all Clemens had requested of the architect Edward Tuckerman Potter was a red brick house. The extravagant High Victorian Gothic home that Potter eventually designed turned out to be a landmark of American architecture.

Clemens spent seventeen years (1874–91) at his Hartford home. Dividing his time between his Hartford house, summers in Elmira and travels in Europe, Clemens had some of his most productive years as writer, authoring such classics as *The Adventures of Tom Sawyer* (1876), *The Prince and the Pauper* (1881), *Life on the Mississippi* (1883), *Adventures of Huckleberry Finn* (1885) and *A Connecticut Yankee in King Arthur's Court* (1889). It was also in this house that he and Livy raised their three daughters—Susy (born 1872), Clara (born 1874) and Jean (born 1880)—making these years among his happiest as well. One of his most frequent houseguests was his friend, the author William Dean

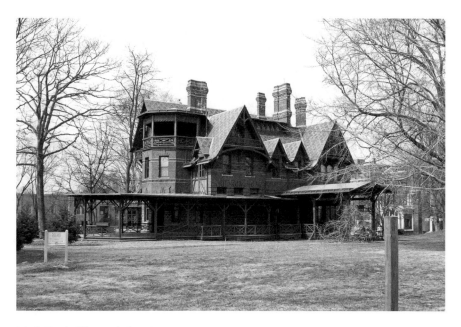

Mark Twain House. *Author photo.*

Howells. Clemens would entertain dinner guests many nights a week and maintained an extensive staff of servants, including a butler, a cook, maids and a coachman who lived with his family in the upper level of the carriage house next door.

Eventually, the financial strain of maintaining this lifestyle and a string of bad investments forced Clemens to shutter the house and move his family to Europe in 1891. Plans to eventually return to their Hartford home were shattered in 1896 by the death of eldest daughter Susy. Her passing made it too hard for Livy to return, and the Clemenses sold the house in 1903. In the twentieth century, the house went through many changes, being rented out for the Kingswood School for Boys and later being subdivided into apartments. A group of preservationists led by Katharine Seymour Day acquired the house to save it from demolition in 1929. Its restoration as a museum was finally completed in 1974, in time for the centennial of its construction. A modern museum and visitor center next door, designed by Robert A.M. Stern, was opened in 2003.

Across the lawn from the Mark Twain House is another flamboyant Victorian residence.

24. Katharine Seymour Day House

The house that now bears the name of Harriet Beecher Stowe's grandniece was built in 1884 for Franklin Chamberlin. He had originally constructed the Stowe House and had also sold Mark Twain the land on which his house was built. Chamberlin hired architect Francis Kimball to design his extravagant Victorian home. Later owned by Willie Olcott Burr, publisher of the *Hartford Times* newspaper, the house was purchased by Katharine Seymour Day in 1940. Today, the Chamberlin-Burr House is named in her honor and contains the offices and research library of the Harriet Beecher Stowe Center.

Return to Farmington Avenue and note the apartment building across the street, on the corner of Farmington and Gillett Street.

25. 334–344 Farmington Avenue

The history of this corner dramatically illustrates the changes that occurred in Asylum Hill in the transition from the late nineteenth to the early twentieth century. In 1865, Caleb M. Holbrook built a stately French Second Empire–style mansion and adjacent carriage house here. Farmington Avenue was then lined with many such residences, surrounded by spacious lawns. The Holbrook House was later demolished, and this apartment building, built in 1917, now occupies the site. Amazingly, the mansard-roofed Holbrook carriage house survived into the twenty-first century. Heavy snows finally caused the slate roof to cave in, and the structure was demolished in January 2011.

In the same block as this apartment building are two houses that do survive. The Gilbert W. Chapin House at 350 Farmington Avenue was built in 1898. Its Georgian Revival design is by Ernest Flagg. Next door, at 360 Farmington Avenue, is a Queen Anne–style house, designed by Isaac A. Allen Jr. It was built for Mary Rowell Storrs, widow of Zalmon A. Storrs, treasurer of the Society for Savings downtown. The Storrs House is now home to the Hartford Children's Theatre.

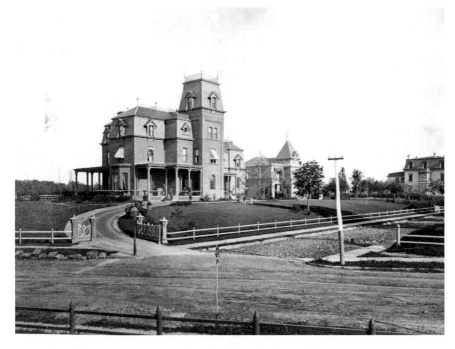

C.M. Holbrook House, 340 Farmington Avenue. *Harriet Beecher Stowe Center, Hartford, Connecticut.*

26. Immanuel Congregational Church
370 Farmington Avenue

Immanuel is the successor to two earlier congregations that moved west from downtown Hartford. Pearl Street Church, founded in 1852, built this church in 1899 and took the name Farmington Avenue Church. In 1914, the church merged with Park Church, and the joined congregation took the new name Immanuel Congregational Church. Architect Ernest Flagg drew on Roman antecedents and the Colonial Revival style in his design for the building. Mark Twain, on a return visit to Hartford, dubbed it the "Church of the Holy Oil Cloth" because the green and yellow tiles on its exterior reminded him of the patterns used on kitchen floors before the invention of linoleum.

Turn right onto Woodland Street.

27. Town and County Club
22 Woodland Street

This Colonial Revival house, designed by Hapgood & Hapgood, was built in 1895 for Theodore Lyman, a prominent attorney. In 1925, it was purchased by the Town and County Club, a social club for women. It added a ballroom, a dining room and a kitchen in 1930.

28. Colonel Lewis R. Cheney House
40 Woodland Street

Designed by William C. Brocklesby, this is another Colonial Revival house built in 1895. A member of a family that owned a large silk manufacturing company in Manchester, Connecticut, Lewis R. Cheney was a colonel in the Connecticut National Guard and served as mayor of Hartford from 1912 to 1914.

29. Melancthon W. Jacobus House
39 Woodland Street

Built in 1908, this house is also the work of Brocklesby, although this time in the Tudor Revival style. Melancthon W. Jacobus (1855–1957) was dean of the Hartford Theological Seminary and Hosmer professor of New Testament exegesis. The house now contains the offices of the Connecticut State University System.

The next house is set well back from Woodland Street and faces south.

30. Perkins-Clark House
49 Woodland Street

Unlike its neighbors on Woodland Street, the Perkins-Clark House is a contemporary of the early homes of neighboring Nook Farm. Constructed in 1861, it is an excellent example of a Romantic Gothic Revival villa of the period. It was built for Charles E. Perkins, a lawyer who was the son of Mary Beecher Perkins. Later owned by probate Judge Walter Clark, the house now contains the offices of an architectural firm.

From Woodland Street, turn right onto Niles Street. Take the next right onto Gillett Street. The next house is on the right side of the street.

31. Alanson Trask House
57 Gillett Street

Built in 1888, the Task House combines a Queen Anne–style form with Romanesque Revival details, like the striking entry arch.

Return to Niles Street and follow it until it ends at Sigourney Street.

32. Trinity Episcopal Church
120 Sigourney Street

In 1860, the Episcopalians of Asylum Hill moved the former Unitarian Church of the Savior from the corner of Trumbull and Asylum Streets downtown to Sigourney Street to serve as their new church (see Tour 2). The present church, designed by Frederick C. Withers, replaced it in 1892. The tower, by LaFarge & Morris, was not added until 1912.

To return to this tour's starting point, make a right on Sigourney Street and a left on Farmington Avenue or a left on Sigourney Street and a right on Asylum Avenue. Follow either avenue back toward downtown.

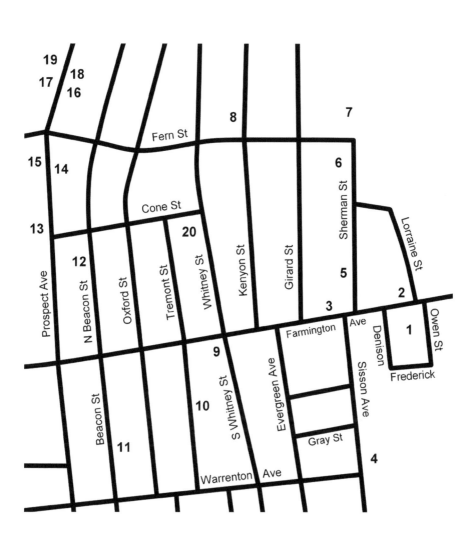

West End South

A fter the Civil War, developers began to lay out residential streets in the open farmland of Hartford's West End. A recession in the late 1870s slowed development, but construction proceeded in the 1890s through the 1920s. Today, the West End is a residential neighborhood, with houses representing many architectural styles.

This tour focuses on the section of the West End around Farmington Avenue, the neighborhood's main commercial street, out to Prospect Avenue, which forms the border with the town of West Hartford. From Asylum Hill in the previous tour, simply continue west on Farmington Avenue, past the intersection with Woodland Street. To pass through the area of this tour's first stop, make a loop by turning left on Denison Street, left on Frederick Street and left on Owen Street.

1. Little Hollywood

The apartment buildings on Denison, Frederick and Owen Streets were built in the 1920s and were designed by such architects as George H. Matthews, Henry H. Beckanstein, Burton Sellew, Rocco D'Avino and Dunkelberger & Gelman. Popular with single women working for the insurance companies, the area became known as "Little Hollywood."

Turn left on Farmington Avenue and note the Victorian-looking building on the west corner of Lorraine Street.

2. Care Endodontics
463 Farmington Avenue

This is actually not a Victorian house at all but rather a dentist's office built in 2007. It was designed to resemble a Victorian house to better fit in with neighboring structures in the West End and Asylum Hill. The late nineteenth-century look of its siding disguises the fact that it is made of vinyl.

Continue heading west on Farmington Avenue. Past the intersection with Sisson Avenue on the right is a cream-colored building with an ornate façade.

3. Colonial Theater
488–492 Farmington Avenue

Designed by James A. Tuck, this building was constructed in 1926 as a luxurious 1,200-seat theater. It soon transitioned from vaudeville to movies, and in 1961 it was converted to Cinerama. By the early 1980s, it was in a dilapidated state and was eventually closed. In the early 2000s, the vacant building was completely gutted, leaving only its fine Colonial Revival façade. The interior was rebuilt to become a restaurant.

Continue west on Farmington Avenue and turn left on Evergreen Avenue. Head south on Evergreen Avenue and turn left on Warrenton Avenue. Turn left on Sisson Avenue and look for the Italianate-style house on the right.

4. Albert Sisson House
170 Sisson Avenue

Albert L. Sisson ran a successful meat market in the Sisson Block, which once stood on Main Street. He built this house in 1867 on Hubbard Street, which was renamed Sisson Avenue in his honor in the 1870s. In 1902, the house was acquired by the cathedral corporation of the Hartford Catholic Diocese and was given to the Sisters of the Good Shepherd for use as a home for wayward girls. The house was expanded in 1905, and additional buildings, including Marian Hall and Euphrasia Hall, were constructed on the estate in the 1920s. The "House of the Good Shepherd" complex was sold by the sisters in 1979 and today serves as senior housing.

Continue north on Sisson Avenue. Turn right on Farmington Avenue and then immediately left on Sherman Street. Continue to the twin mansard-roofed Second Empire houses with towers on the left.

5. Adeline Chadwick & Nathan Bosworth Houses
21 and 25 Sherman Street

These two houses were built by John R. Hills, builder, and William Blevins, stone dealer, in 1877 and 1878 as investment properties.

Continue along Sherman Street to the very modern structure on the left.

6. Hartford Seminary
77 Sherman Street

The origins of the Hartford Seminary go back to the opening of the Theological Institute of Connecticut in 1834 in East Windsor Hill, Connecticut. In 1865, the institute was moved to Hartford and in 1885 changed its name to the Hartford Theological Seminary. After occupying several old houses on Prospect Street, the seminary was moved in the

1880s to a campus on Broad Street, across from the old Hartford High School. In the 1920s, the seminary moved again to a new Gothic campus. In 1972, the seminary was changed from being a traditional residential divinity school and became an interdenominational theological center. It was decided to sell the old campus and construct this single building, designed by Richard Meier, a postmodern architect known for his use of the color white. The new structure was built between 1978 and 1981.

There is a Gothic-style campus straight ahead.

7. University of Connecticut School of Law
65 Elizabeth Street

The land here was purchased by the Hartford Seminary in 1913, and the first buildings were constructed in 1922–29. They were designed by the firm of Allen & Collens, architects of Riverside Church in New York City. The UConn Law School was founded in 1921 and moved to this campus in 1984.

Follow Sherman Street as it curves to the left and becomes Fern Street. Turn right on Giard Avenue and left on Elizabeth Street. Take the next left onto Kenyon Street.

8. Kenyon Street Houses

Starting in 1870, real estate developer Eugene L. Kenyon laid out Kenyon, Whitney, Tremont, Oxford and North Beacon Streets. Today, all of these streets are filled with interesting late Victorian and early twentieth-century houses. The blocks of Kenyon Street as you head south are one place to explore the neighborhood. They are particularly notable for having a number of houses built by William H. Scoville.

The owner of a business that produced millwork, William H. Scoville (1862–1932) lived in a house he built in 1900 at 190 Wethersfield Avenue. A prolific builder and developer, he oversaw the design, construction and

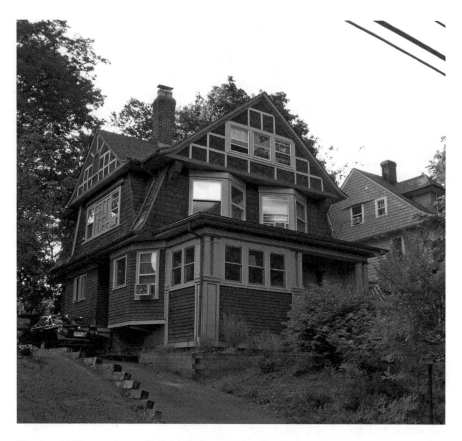

Number 79 Kenyon Street. Built by William H. Scoville. *Author photo.*

sale of numerous homes for middle-class families. His houses usually follow a similar basic plan, but each is given distinct architectural details to create variety. In this vicinity, he built the houses at 102, 109, 127, 129 and 133 Kenyon Street in the 1890s, as well as the houses at 75, 79, 83 and 87 Kenyon Street in 1904.

There are other notable houses here, including the dramatic 1898 house at 139 Kenyon Street, the house of lumber dealer Charles A. Atkins built in 1900 at 65 Kenyon Street and the house at 96 Kenyon Street, which was the first to be built on the newly opened street by Eugene Kenyon in 1870.

Follow Kenyon Street south and turn right on Farmington Avenue.

9. United Methodist Church
571 Farmington Avenue

At the southwest corner of Farmington Avenue and South Whitney Street is a church dedicated in 1905 as the First Methodist Church, which later merged with St. Paul's Methodist Church (see Tour 8) and South Park Methodist Church (see Tour 5).

Continue on Farmington Avenue and turn left onto Tremont Street.

10. Tremont Street Houses

Tremont Street, between Farmington Avenue on the north and Warrenton Avenue on the south, is another block with houses, both single and two-family, designed by William H. Scoville. The houses at 2–4, 6–8, 10–12 and 14–16 Tremont Street were built in 1908 and those at 40–42, 44–46, 52–54, 56–58, 60, 68, 70, 72, 74, 76, 78 and 80 Tremont Street in 1906.

At the south end of Tremont Street, turn right on Warrenton Avenue. Continue to Beacon Street and turn right.

11. Lucy Barbour House
172 Beacon Street

In 1872, developers Joseph Woodruff and Burdett Loomis followed Eugene Kenyon's lead and extended southward the streets he had laid out in 1870. This house, one of the earliest to be built on the newly opened Beacon Street, was constructed in about 1875. In the 1890s, Lucy Barbour ran a school for girls here.

Continue north on Beacon Street. After the intersection with Farmington Avenue, it becomes North Beacon Street.

12. North Beacon Street Houses

Returning to the section of the West End first laid out by Eugene Kenyon, this block of North Beacon Street has many houses built between 1900 and 1904 by Albert W. Scoville (1852–1941), the older brother of William H. Scoville. These are located at 25, 31, 35, 39, 43, 49, 53, 57 and 63 North Beacon Street. Additional Albert Scoville Houses are found in the blocks north of Cone Street.

Turn left on Cone Street and right on Prospect Avenue. This street is the border between Hartford and West Hartford, which became a separate town in 1854. Buildings on the east side of Prospect Avenue are in Hartford, while those on the west side are in West Hartford.

13. Charles E. Shepard House
695 Prospect Avenue, West Hartford

The large "Swiss Chalet" house on the left, designed by Edward T. Hapgood, was built in about 1901 for Charles E. Shepard, who worked for Aetna Life Insurance. The residence was acquired by the Oxford School (now Kingswood-Oxford School) in 1924 and housed a private middle school. Additional facilities were attached to the original house over the years, but these were removed, and the house's exterior was restored when the entire property was converted for use by the town of West Hartford for a new public middle school. The house was converted to office, library and classroom space and attached to the Bristow Middle School building at 34 Highland Street that opened in 2005.

14. Henry Dwight Bradburn House
726 Prospect Avenue

This eclectic house was built in 1900, the year Henry Dwight Bradburn retired as manager of the Nonotuck Paper Company of Holyoke, Massachusetts.

15. Dr. Michael Gill House
735 Prospect Street, West Hartford

Built in about 1901, this was the home of Dr. Michael Gill, a physician. His son, Brendan Gill, grew up here and attended the Kingswood School nearby. Brendan Gill became a well-known writer and contributor to the *New Yorker* magazine. He was also a noted preservationist.

16. Isidore Wise House
820 Prospect Avenue

Isidore Wise and his wife, Selma, lived in this house, which is located behind a stone wall and hedge. Built in 1907, it was designed by Isaac A. Allen Jr. Wise was a civic leader and head of the Wise, Smith & Company department store (see Tour 2).

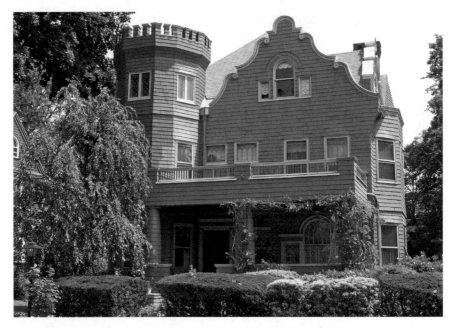

Henry Dwight Bradburn House. *Author photo*.

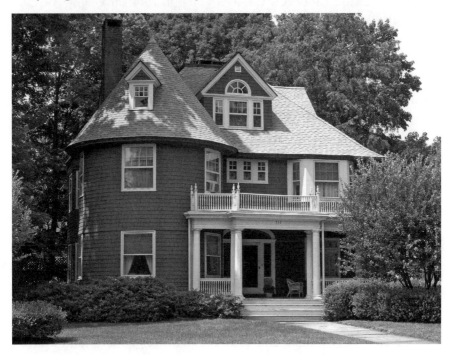

Dr. Michael Gill House. *Author photo*.

17. William Augustus Erving House and Henry Wood Erving House
821 and 825 Prospect Avenue, West Hartford

These two Queen Anne houses were built in about 1880 for two brothers, William Augustus Erving and Henry Wood Erving. William Augustus Erving was secretary of the Hartford County Mutual Fire Insurance Company and later followed his father, Daniel Dodge Erving, as president of the company. Henry Wood Erving was chairman of the board of the Connecticut River Banking Company.

18. George W. Ellis House
830 Prospect Avenue

This is a dramatic Tudor Revival house, built in 1902 for George W. Ellis, who worked at Travelers Insurance Company.

19. Burdett Loomis House
837 Prospect Avenue, West Hartford

Burdett Loomis was one of the early developers of the West End. In about 1885, he bought an 1840s Greek Revival–style farmhouse and added a Queen Anne addition to the front. At the time, this house was considered to be out in the country.

In 1873, Loomis opened a trotting horse park on New Park Avenue in West Hartford. This later evolved into Charter Oak Park and, by the early twentieth century, Luna Park, a popular amusement park.

Continue north on Prospect Avenue. Before the intersection with Asylum Avenue, there is a small circular drive on the right. Part of Elizabeth Park, this drive provides a view of downtown Hartford in the distance. Exit the circular drive and turn left to head back south on Prospect Avenue. Turn left on Fern Street, continue three blocks and turn right on Whitney Street. There is a large school at the corner of Cone Street.

20. Noah Webster School
1 Cone Street

This building was constructed in 1900 as an elementary school, named for the famous lexicographer and political writer Noah Webster. He was born in West Hartford in 1758 in a house that is now a museum at 227 South Main Street. The Noah Webster School was designed in the Tudor Revival style by architect William C. Brocklesby. Many additions have been made to the building over the years.

Continue south on Whitney Street and turn left on Farmington Avenue to return to this tour's starting point.

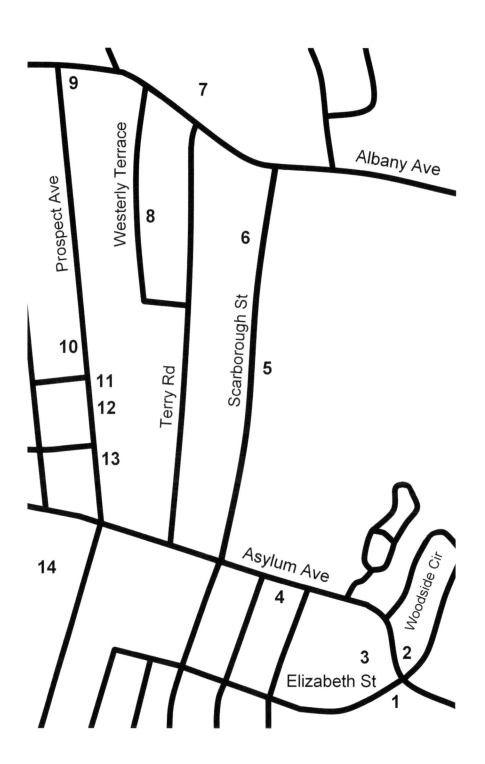

West End North

This tour presents the northern section of the West End, between Asylum Avenue and Albany Avenue. The houses of some of Hartford's wealthiest residents are located here. It was also home to one of the city's most notable literary figures, the poet Wallace Stevens.

Head west on Asylum Avenue from the Asylum Hill Neighborhood (Tour 10). Turn left on Elizabeth Street. The building on the left is home to the Connecticut Historical Society. Turn left into the society's driveway and follow it to the left, in front of the building.

1. Connecticut Historical Society
1 Elizabeth Street

The society is headquartered in a house built in 1928 for Curtis H. Veeder and his family. Born in Alleghany, Pennsylvania, in 1862, Veeder was an engineer who got his first patent at age eighteen. He founded the Veeder Manufacturing Company in Hartford in 1895. The company's first product was one of Veeder's inventions, a bicycle cyclometer. Promoted with the slogan "It's Nice to Know How Far You Go," these devices measure the distance a bike has traveled by counting the number of rotations made by

the wheels. The company later merged with the Root Company of Bristol, Connecticut, to form Veeder-Root, which continues to produce counting and computing devices today.

In 1950, Veeder's widow, Louise Stutz Veeder, sold the house to the Connecticut Historical Society. Founded in 1825, the society had been based for almost a century in the Wadsworth Atheneum (see Tour 1). Expanding the original house, which was designed by William F. Brooks, the historical society constructed two large additions. Visitors to the society's museum and research library can explore its extensive collections of manuscripts, printed material, artifacts and images.

Exit the society's driveway by turning left onto Asylum Avenue. As you pass the intersection with Elizabeth Street, there is a house on the right, at the intersection of Asylum and Woodside Circle.

2. Frank L. Prentice House
1 Woodside Circle

One of the West End's most picturesque houses, this residence resembles a French chateau. It was built in 1926 for Frank L. Prentice, vice-president and treasurer of the Society for Savings (Tour 2). It was designed by his son, T. Merrill Prentice, who had just returned from studying at the École des Beaux-Arts in Paris.

Continue on Asylum Avenue.

3. Former Campus of the Hartford College for Women

As Asylum curves to the northwest, the buildings to the left constitute the former campus of the Hartford College for Women. This institution was founded in 1933 as a junior college branch of Mount Holyoke College, which is located forty miles north of Hartford in South Hadley, Massachusetts. In 1939, the college became an independent institution and in 1958 moved here, to the former estate of Charles F.T. and Mary

Hillyer Seaverns. In 1927, the couple founded what is today the Children's Museum, currently located at 950 Trout Brook Drive in West Hartford. The Seaverns House, built in 1917 at the corner of Asylum Avenue and Girard Avenue, was designed by Goodwin, Bullard & Woolsey. In 1991, the college merged with the University of Hartford, whose main campus is at 200 Bloomfield Avenue in West Hartford. The university closed the Hartford College for Women in 2003.

4. Johnson-Steadman House
1335 Asylum Avenue

At the other corner of Girard and Asylum Avenues is a mansion built in 1913 in the Jacobethan style to plans by Erick K. Rossiter. It was the home of sisters Mabel and Eleanor Johnson and their aunt, Elizabeth Stedman. Since 1951, it has been the offices of the Episcopal Diocese of Connecticut. The first Anglican diocese outside the British Isles, it officially began with the consecration of Samuel Seabury as bishop of Connecticut in Aberdeen, Scotland, on November 14, 1784.

Continue on Asylum Avenue to Scarborough Street and turn right. Scarborough is lined with some of Hartford's finest mansions, many in the Colonial Revival style. Note the distinctive house that is set well back on its lot on the right side of the street.

5. A. Everett Austin Jr. House
130 Scarborough Street

Born in 1900 to wealthy parents, A. Everett Austin Jr., known as "Chick," attended Harvard and developed a passion for art. At age twenty-six, he became director of the Wadsworth Atheneum (see Tour 1). One of the country's most innovative museum directors, Chick Austin made Hartford a center of the art world during his tenure at the Atheneum (1927–44). He built up the Atheneum's collections of both old master paintings and modern art, giving Edward Hopper his first individual museum exhibition

in 1928 and bringing the first major exhibition of Picasso to the United States in 1934.

Austin was also a supporter of the performing arts, staging the premiere of Gertrude Stein and Virgil Thomson's *Four Saints in Three Acts*, which had an all-black cast, and bringing George Blanchine to America. He was frequently at odds with the museum's conservative board, chaired by Charles A. Goodwin, whose niece he married. Austin also founded the fine arts department of Trinity College (see Tour 7).

Chick Austin's house, constructed in 1930, was designed by Leigh H. French Jr. under Austin's direction. A Palladian villa, it was modeled on the 1596 Villa Feretti-Angeli in Dolo, Venezia, Italy. Being only one room deep, the house has often been described as giving the feeling of a stage set. It was the perfect home for Austin, a showman who also performed magic shows as the "Great Osram." In 1985, the house was bequeathed by his widow, Helen Goodwin Austin, to the Wadsworth Atheneum. Tours of the restored house can be arranged through the Atheneum.

Continue north on Scarborough Street to the church on the left.

A. Everett Austin Jr. House. *Author photo.*

6. All Saints Orthodox Church
205 Scarborough Street

The congregation of this Russian Orthodox church was founded in Hartford in 1914. The original church building was on Broad Street, near the state capitol. In 1956, land was purchased on Scarborough Street for a new church. All Saints Orthodox Church was constructed in 1963–64.

Continue to the intersection with Albany Avenue. Another church, on the corner here, is the First Church of Christ, Scientist, completed in 1956. Turn left on Albany Avenue and continue as it heads uphill. Notice the group of buildings below to the right.

7. The Village for Families and Children
1680 Albany Avenue

The Female Beneficent Society, founded in 1809, opened the first Hartford Orphan Asylum in 1831. After 1879, it was housed in a large brick building on Putnam Street. The Asylum later moved to these cottages, built in the 1920s, which formed the Children's Village. The innovative housing method was created to accommodate children in smaller living groups, resulting in a less institutional feel. Today, the nonprofit human services agency continues as the Village for Families and Children.

Continue down Albany Avenue. Turn left onto Westerly Terrace, which has many Colonial Revival and Tudor Revival houses built in the 1920s. Westerly Terrace has a grassy median. Follow the road southward until the median ends and then turn to follow Westerly Terrace back northward. The next house is on the right side, with a stone marker across from it on the median.

8. Wallace Stevens House
118 Westerly Terrace

One of America's most important modernist poets, Wallace Stevens (1879–1955) came to Hartford in 1916 to work for the Hartford Accident and Indemnity Company (see Tour 10). He became a vice-president in 1934, a position he held until his death in 1955. A reclusive man who valued the security of steady employment, he lived with his wife and daughter in this modest house, which he purchased in 1932. Stevens, who did not drive, would walk to work, composing his poetry in his mind as he went. His first book of poems, *Harmonium*, was published in 1923, but widespread recognition only came with the publication of his *Collected Poems* in 1954.

The Wallace Stevens Walk has been created by the Hartford Friends and Enemies of Wallace Stevens, a local nonprofit group. Starting at The Hartford and ending at the Stevens House, the walk is marked by thirteen Connecticut granite stones, each inscribed with a stanza of Stevens's poem "Thirteen Ways of Looking at a Blackbird."

Wallace Stevens House. *Author photo.*

Return to Albany Avenue and turn left. On Bloomfield Avenue, just beyond the intersection with Albany Avenue, can be seen the modernist meetinghouse of the Unitarian Society of Hartford. Dedicated in 1964, it was designed by Victor A. Lundy. Its non-identical supporting piers rise toward the same point in the sky, representing the Unitarian principle of many paths leading to truth.

Turn left on Prospect Avenue.

9. Elisha Wadsworth House
1234 Prospect Avenue

Albany Avenue was once the Albany Turnpike, an important stagecoach route. This Federal-style house on the corner was built in 1828 by Elisha Wadsworth, who operated it as an inn here until 1862.

Continue on Prospect Avenue, which is lined with imposing Colonial Revival mansions.

10. Robert Schutz House
1075 Prospect Avenue, West Hartford

Turned ninety degrees from Prospect Avenue, this house was constructed in 1907 to plans by Charles Adams Platt, a prominent architect and landscape designer. It was built for Robert Schutz, president of the Smyth Manufacturing Company, which still makes bookbinding machines today. The house was also the residence of his son, Robert Schutz Jr., who was an architect. As a trustee and president of the Mark Twain Memorial in the 1950s, Robert Schutz Jr. donated objects he found in the attic of this house to what is now the Mark Twain House and Museum.

Beatrice Fox Auerbach House. *Author photo.*

11. Beatrice Fox Auerbach House
1040 Prospect Avenue

Located at the head of Sycamore Lane is the former residence of Beatrice Fox Auerbach, who was a civic leader and president of G. Fox & Company for almost three decades (see Tour 2). The house was designed in 1911 by LaFarge & Morris, with alterations in 1923 by Frederick C. Waltz.

12. Alfred C. Fuller House
1020 Prospect Avenue

This house, designed by William T. Marchant of Hartford, was built in 1917. In the 1920s, it was the residence of Alfred C. Fuller. Born in Nova Scotia in Canada, Fuller started his first brush company in 1906 and soon moved to

Hartford, incorporating the Fuller Brush Company in 1913. Fuller, whose memoir was titled *A Foot in the Door*, emphasized door-to-door selling. The "Fuller Brush Man" became a familiar sight on streets throughout America.

Fuller was a generous supporter of the Hartt School, a performing arts conservatory that became part of the University of Hartford in 1957. The former Fuller Brush factory, built in 1922 and located at 3580 Main Street in Hartford's North End, now contains employment and social service agencies.

13. The Governor's Residence
990 Prospect Avenue

Near the intersection of Prospect and Asylum Avenues is the mansion that has served as the official residence of the governor of Connecticut since 1945. It was built in 1909 for Dr. George C.F. Williams, a physician and president of the Capewell Horse Nail Company. It was designed by the firm of Andrews, Jacques & Rantoul, with additions made in 1916 by Smith & Bassette.

Continue on Prospect Street. If you turn right on Asylum Avenue, entering West Hartford, you will see Elizabeth Park on your left. There is an entrance to the park on the south side of Asylum, between Sycamore Road and Goff Road. A walk west down Asylum in West Hartford toward Steele Road passes many notable Tudor Revival and Colonial Revival houses on the right. You can also proceed south on Prospect Avenue, where you can enter the park on the right.

14. Elizabeth Park

This park was established in 1897 on land bequeathed to the city by industrialist Charles M. Pond. He had stipulated that it be used as a horticultural park named for his wife, Elizabeth, who had passed away a few years before her husband. Elizabeth Park was landscaped by Olmsted and Son, with gardens designed by the park's first superintendent, Theodore Wirth. The park is internationally famous for its rose garden (planned by

Lake Vista, Elizabeth Park, circa 1905. *Library of Congress, Prints and Photographs Division, Detroit Publishing Company Collection.*

Wirth in 1904), which is the oldest municipally operated rose garden in the United States. Due to later boundary changes, most of the one hundred acres of this park are located in West Hartford, although it is still operated as a Hartford city park.

Return to the tour's starting point by following Asylum Avenue back to the east.

Bibliography

Andrews, Gregory E., and David F. Ransom. *Structures and Styles: Guided Tours of Hartford Architecture.* Hartford: Connecticut Historical Society and Connecticut Architecture Foundation, 1988.

Andrews, Kenneth R. *Nook Farm: Mark Twain's Hartford Circle.* Cambridge, MA: Harvard University Press, 1950.

Courtney, Steve. *"The Loveliest Home That Ever Was": The Story of the Mark Twain House in Hartford.* Mineola, NY: Dover Publications, Inc., 2011.

Gaddis, Eugene R. *Magic Façade: The Austin House.* Hartford, CT: Wadsworth Atheneum Museum of Art, 2007.

Grant, Ellsworth Strong, and Marion Hepburn Grant. *The City of Hartford, 1784–1894: An Illustrated History.* Hartford: Connecticut Historical Society, 1986.

Hosley, William. *Colt: The Making of an American Legend.* Amherst: University of Massachusetts Press, 1996.

Hosley, William, and Shepherd M. Holcombe Sr. *By Their Markers Ye Shall Know Them: A Chronicle of the History and Restorations of Hartford's Ancient Burying Ground.* Hartford, CT: Ancient Burying Ground Association, 1997.

Kuckro, Anne Crofoot, et al. *Hartford Architecture: Hartford Architecture Conservancy Survey*. Hartford, CT: Hartford Architecture Conservancy, 1978–80.

Love, William DeLoss. *The Colonial History of Hartford*. Hartford, CT: self-published, 1914.

McAlester, Virginia, and Lee McAlester. *A Field Guide to American Houses*. New York: Alfred A. Knopf, Inc., 1984.

Murphy, Kevin. *Crowbar Governor: The Life and Times of Morgan Gardener Bulkeley*. Middletown, CT: Wesleyan University Press, 2011.

Nenortas, Tomas. *Victorian Hartford*. Dover, NH: Arcadia Publishing, 2005.

———. *Victorian Hartford Revisited*. Dover, NH: Arcadia Publishing, 2007.

O'Nan, Stewart. *Circus Fire: A True Story*. New York: Doubleday, 2000.

Ransom, David F. *George Keller, Architect*. Hartford, CT: Hartford Architecture Conservancy and the Stowe-Day Foundation, 1978.

Trumbull, J. Hammond. *Memorial History of Hartford County*. Boston: Edward L. Osgood, 1886.

Van Why, Joseph S. *Nook Farm*. Hartford, CT: Stowe-Day Foundation, 1975.

Weaver, Glenn, and Michael Swift. *Hartford, Connecticut's Capital: An Illustrated History*. Sun Valley, CA: American Historical Press, 2003.

Woodward, P.H. *Hartford, Conn. as a Manufacturing, Business and Commercial Center: With Brief Sketches of its History, Attractions, Leading Industries and Institutions*. Hartford, CT: Hartford Board of Trade, 1889.

Index

About the Author

D aniel Sterner majored in history at Wesleyan University and earned a master's degree in Middle Eastern studies at the University of Chicago. He has been a guide at the Mark Twain and Harriet Beecher Stowe Houses in Hartford and the Webb-Deane-Stevens Museum in Wethersfield, Connecticut. His website, Historic Buildings of Connecticut (historicbuildingsct.com), won an award from the Hartford Preservation Alliance in 2008.

Visit us at
www.historypress.net